Retrospecter

Micro-Visual Poems by Ashley Parker Owens

ISBN: 9781078325622

Copyright 2019
All Rights Reserved

Contents

Illusionist ... 5

Bird-Like ... 6

Divide .. 7

Delusional ... 8

Vestige ... 9

Egnostic ... 10

Stolen ... 11

Cry .. 12

Lone .. 13

Lost ... 14

United .. 15

Elixer .. 16

Hubris .. 17

Egobese .. 18

Decoy ... 19

Rumor Monger ... 20

Sorry Sorrow .. 21

Denial ... 22

Vestige 2 .. 23

Broker .. *24*

Mortal .. *25*

Hurt .. *26*

Wax .. *27*

Drift .. *28*

Escape ... *29*

Satisfied .. *30*

Cowpuncher ... *31*

Dreamer ... *32*

Sand .. *33*

Vacillator ... *34*

Bio .. *35*

Artist statement ... *35*

Acknowledgements ... *35*

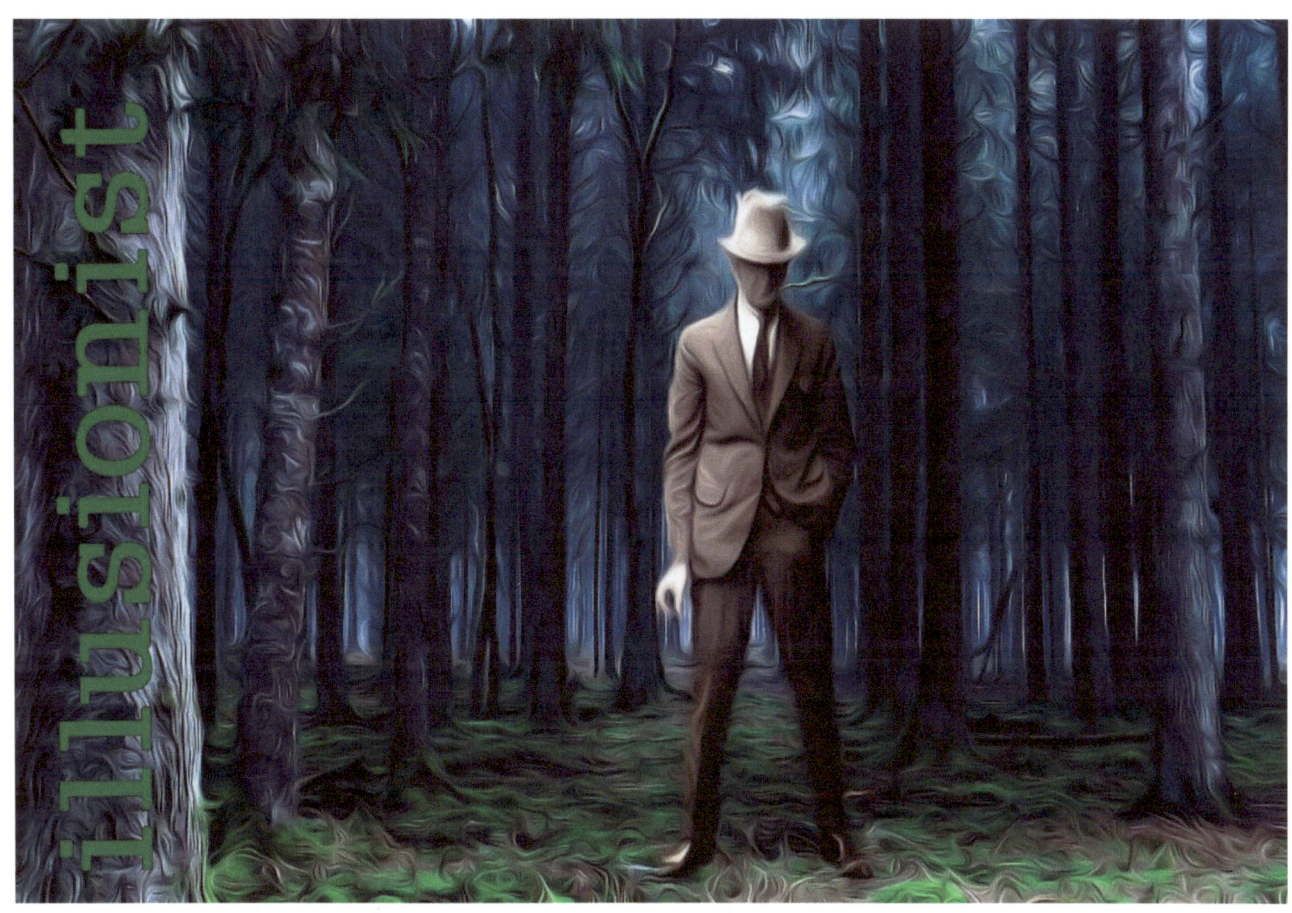

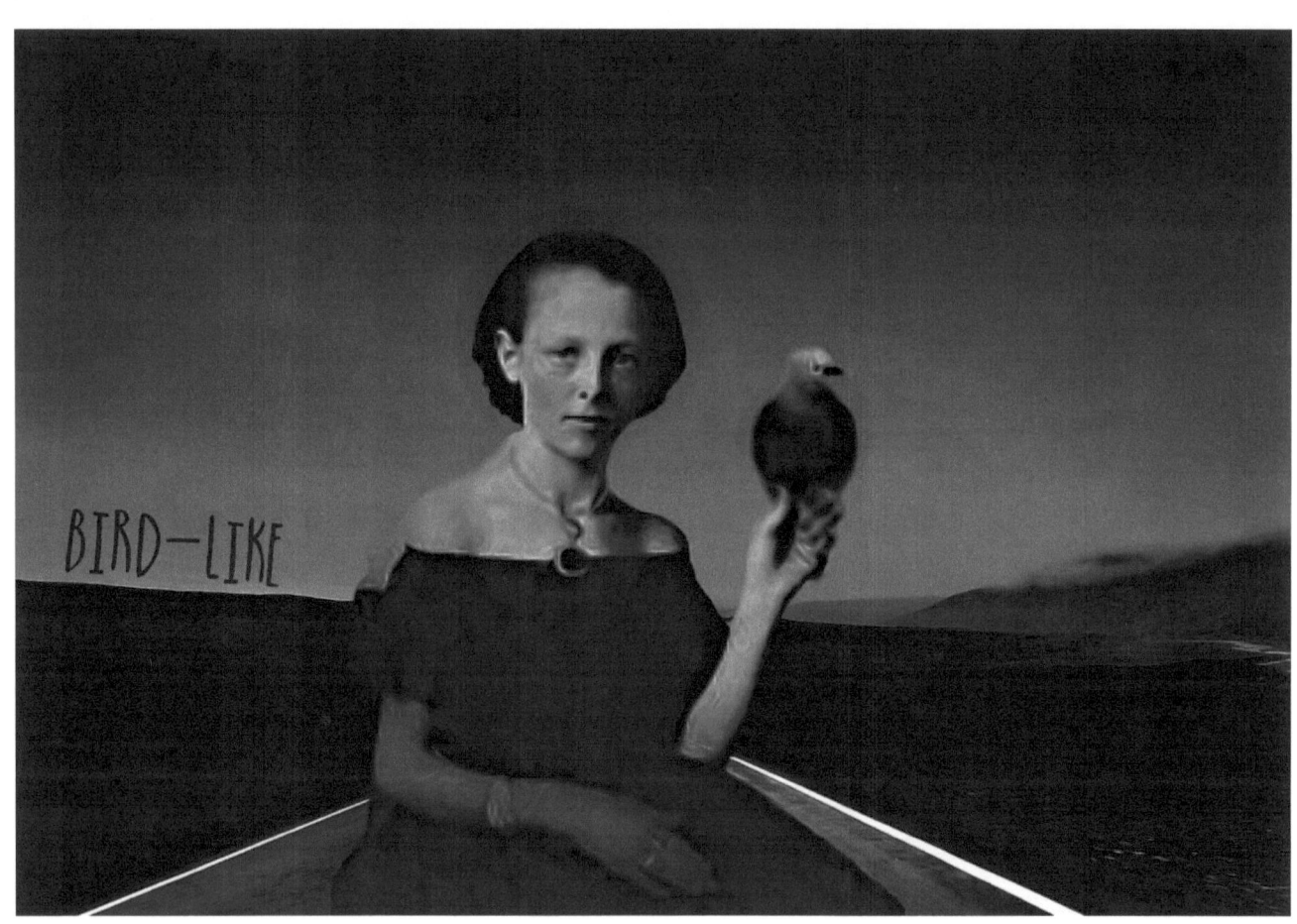

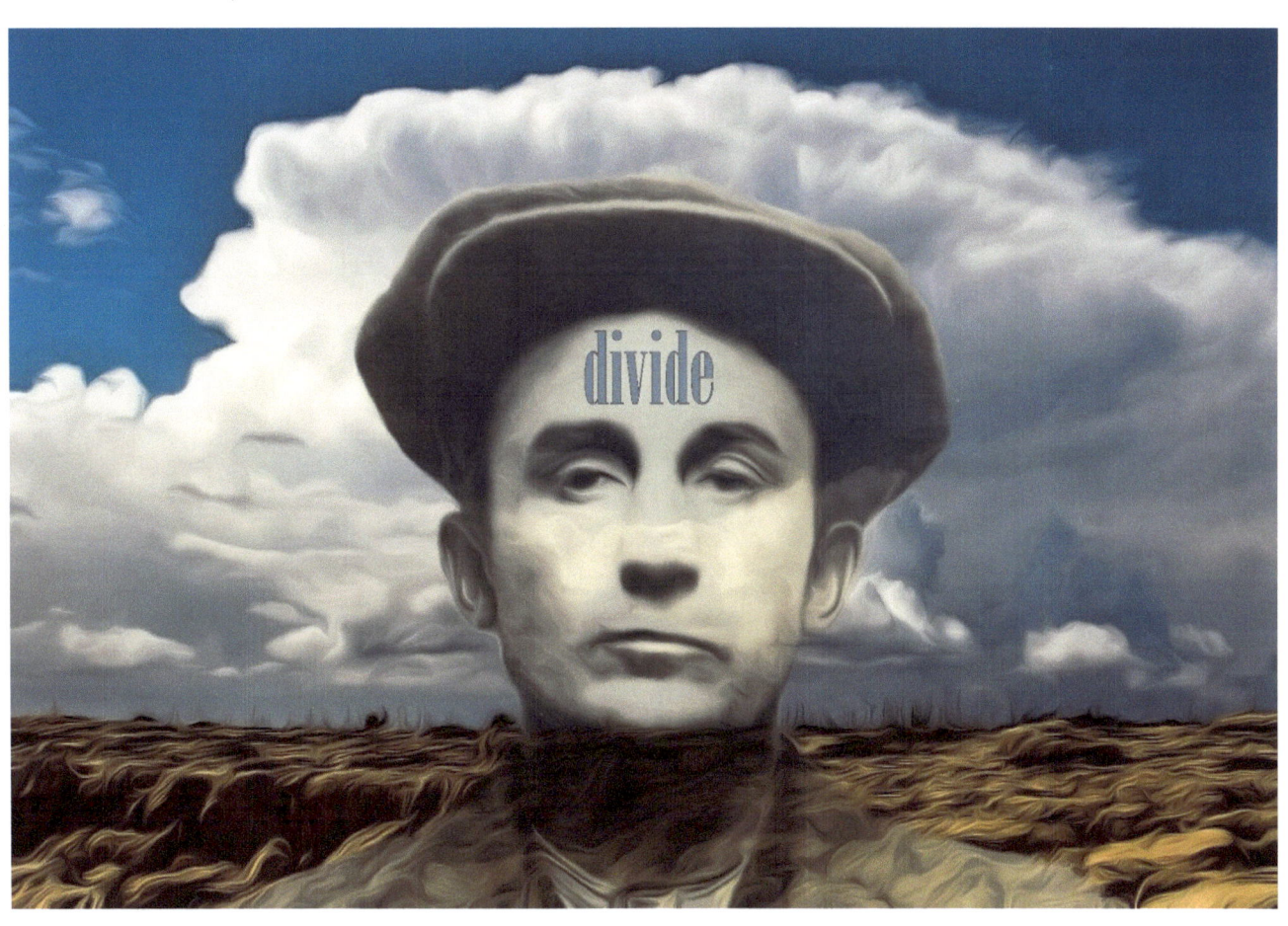

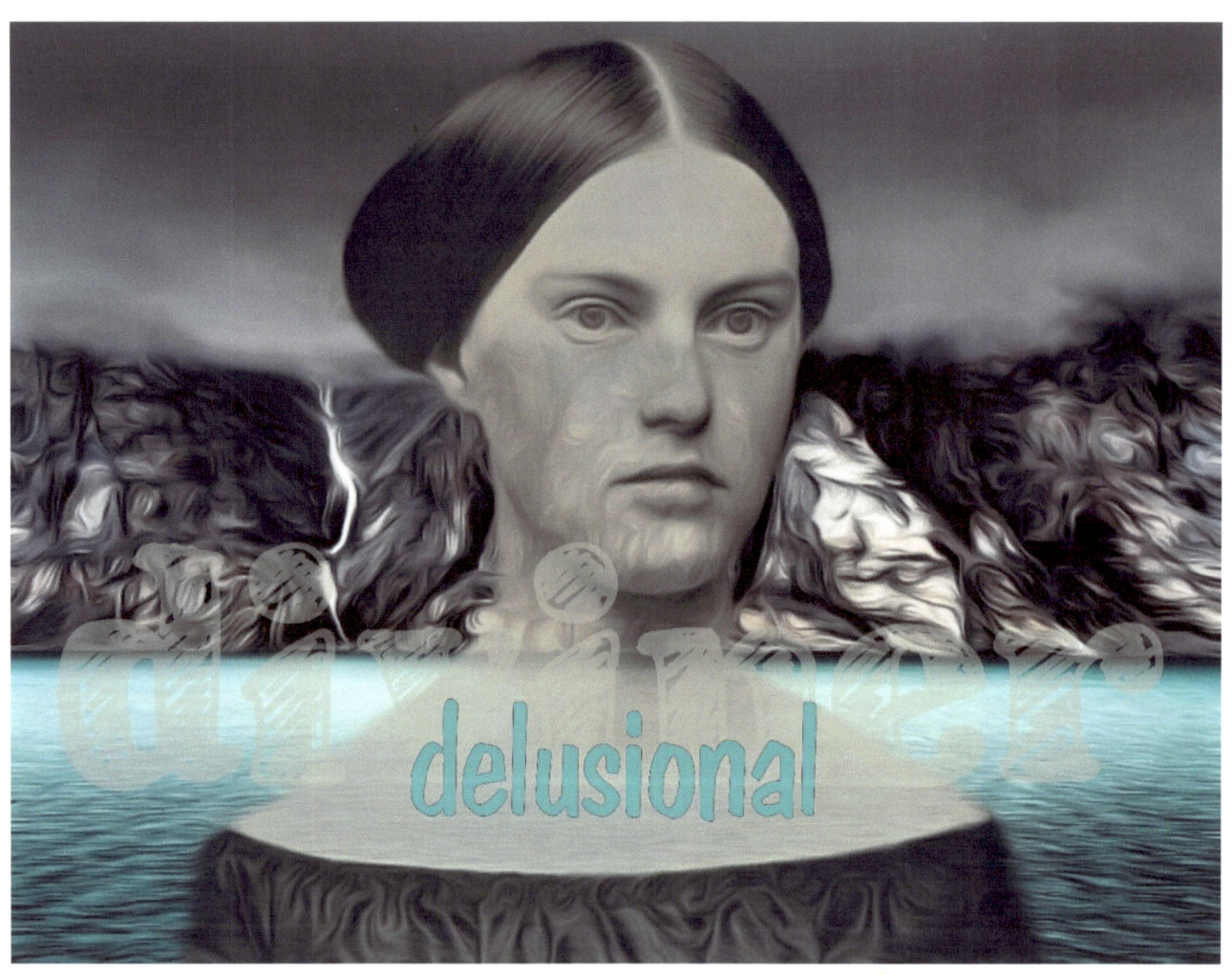

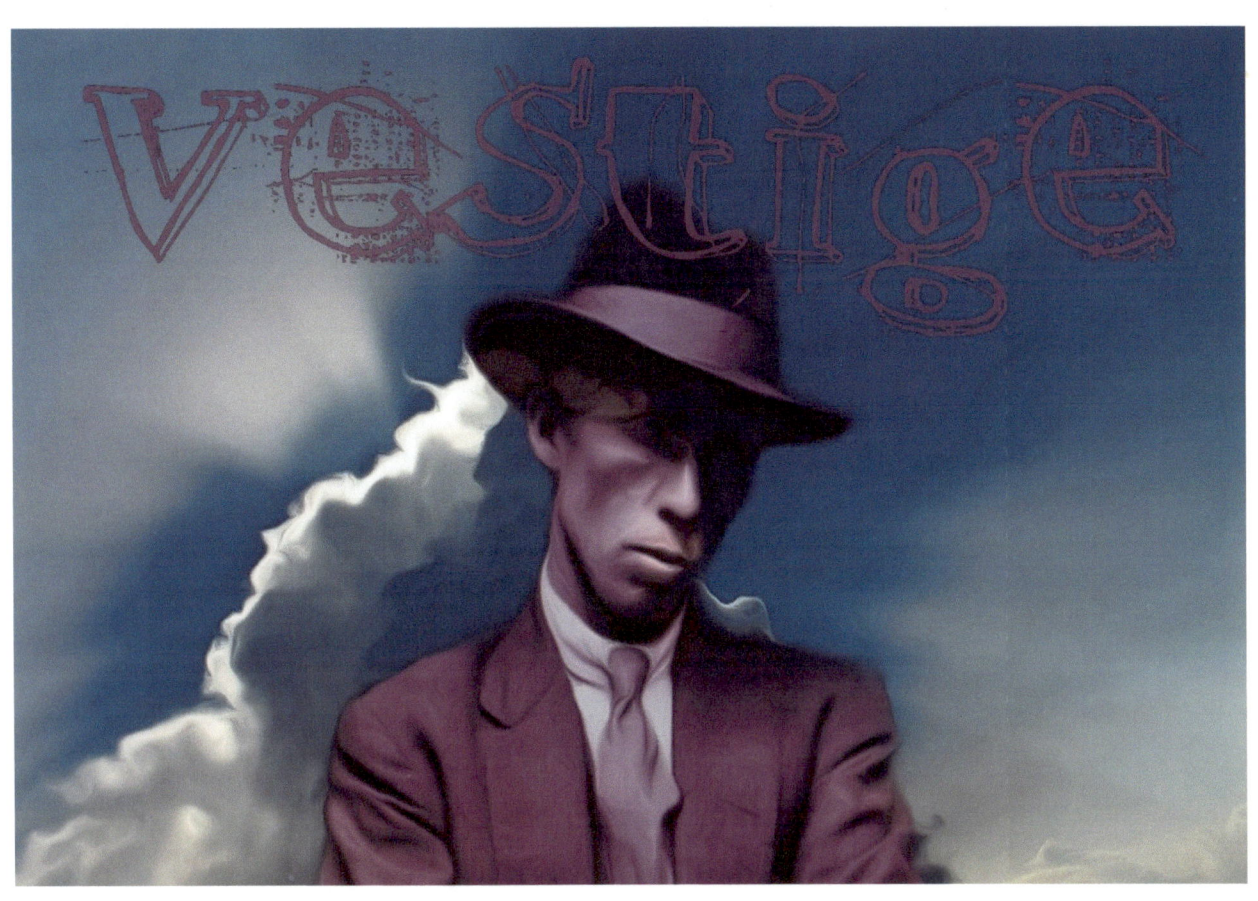

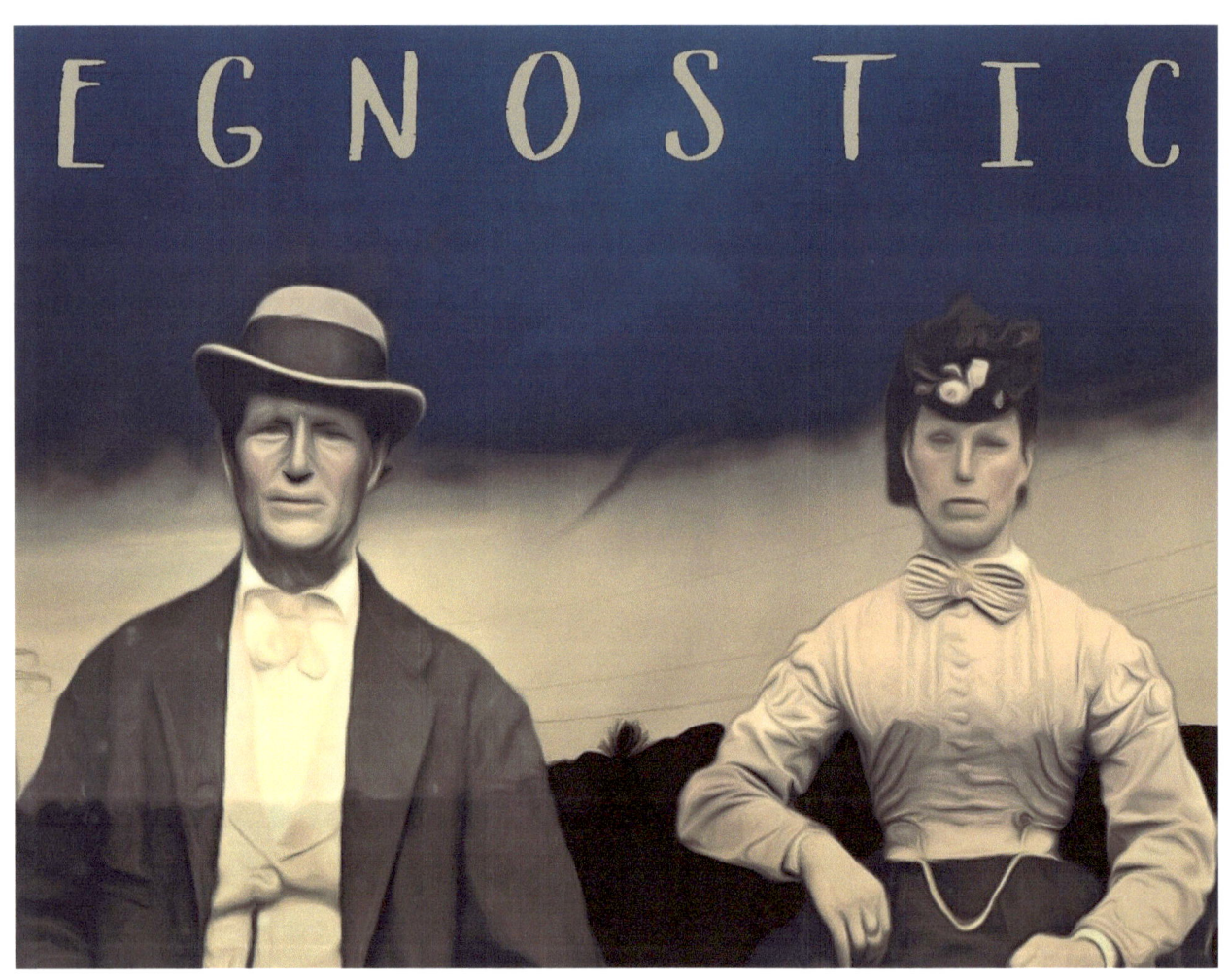

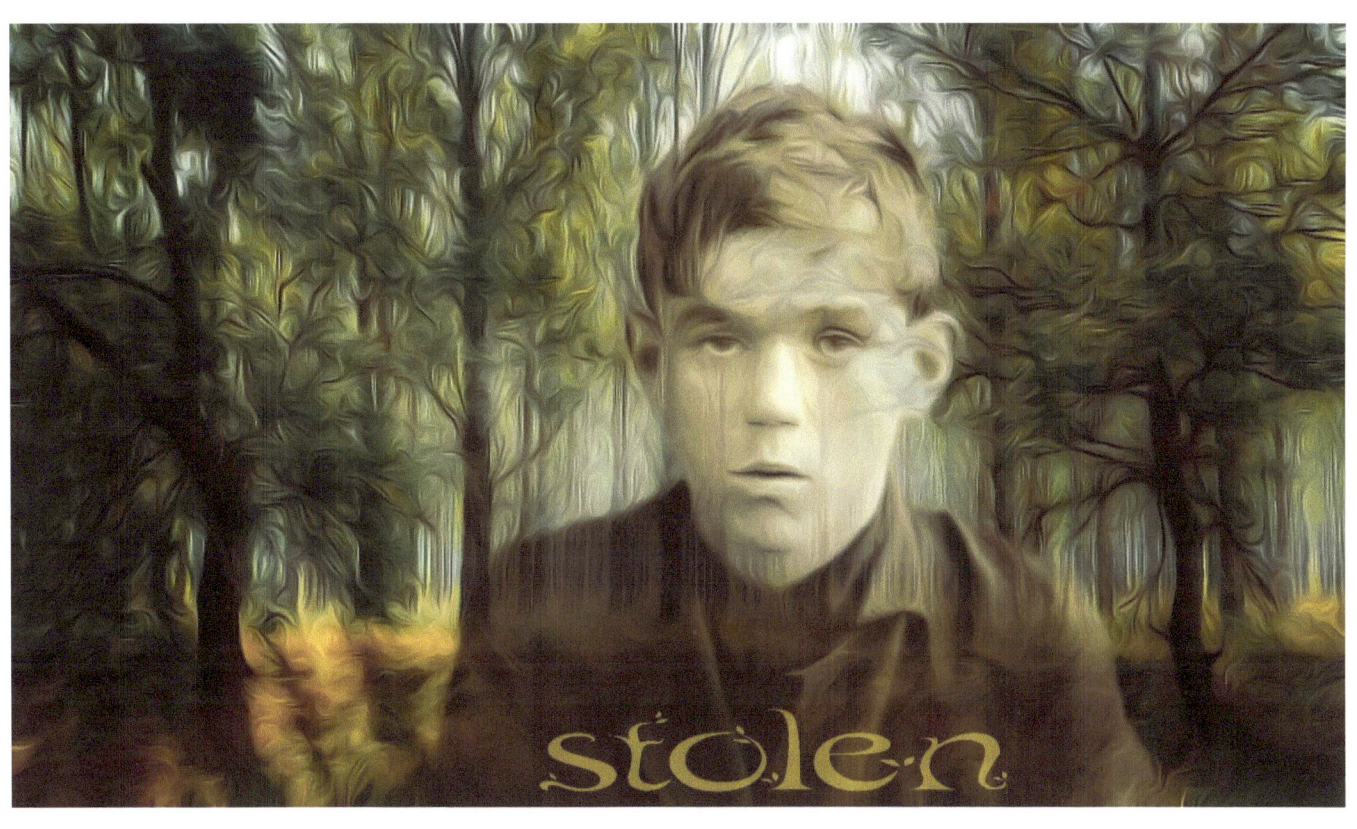

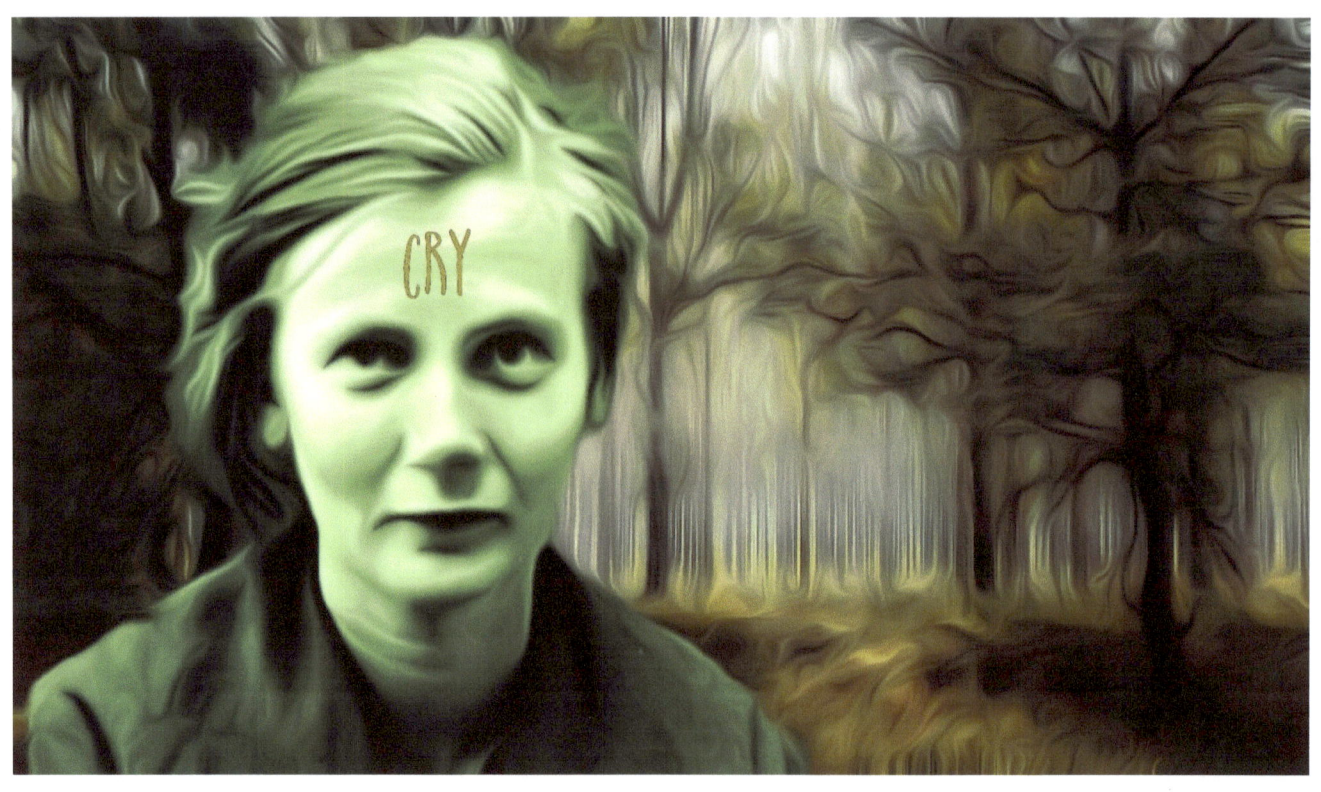

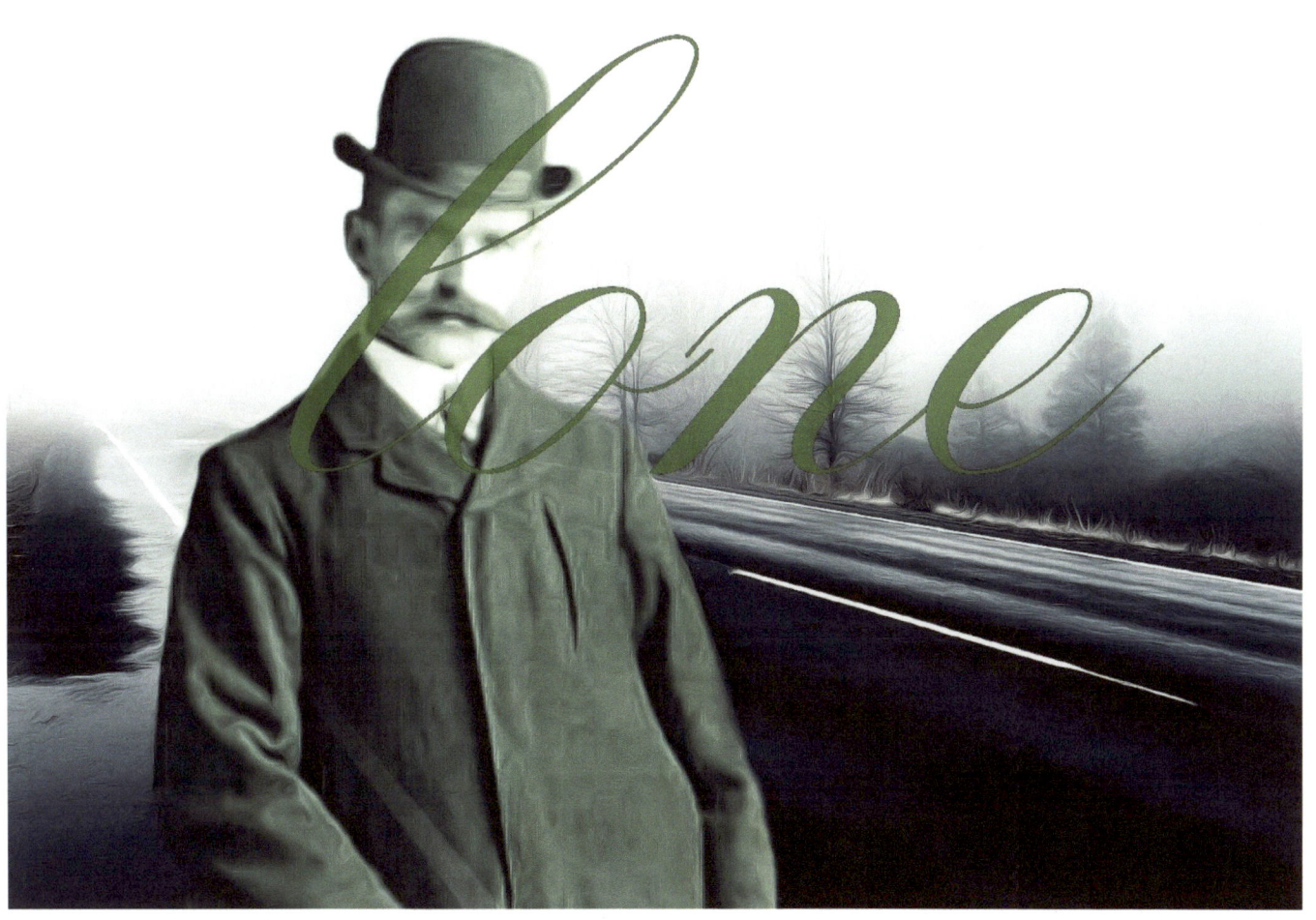

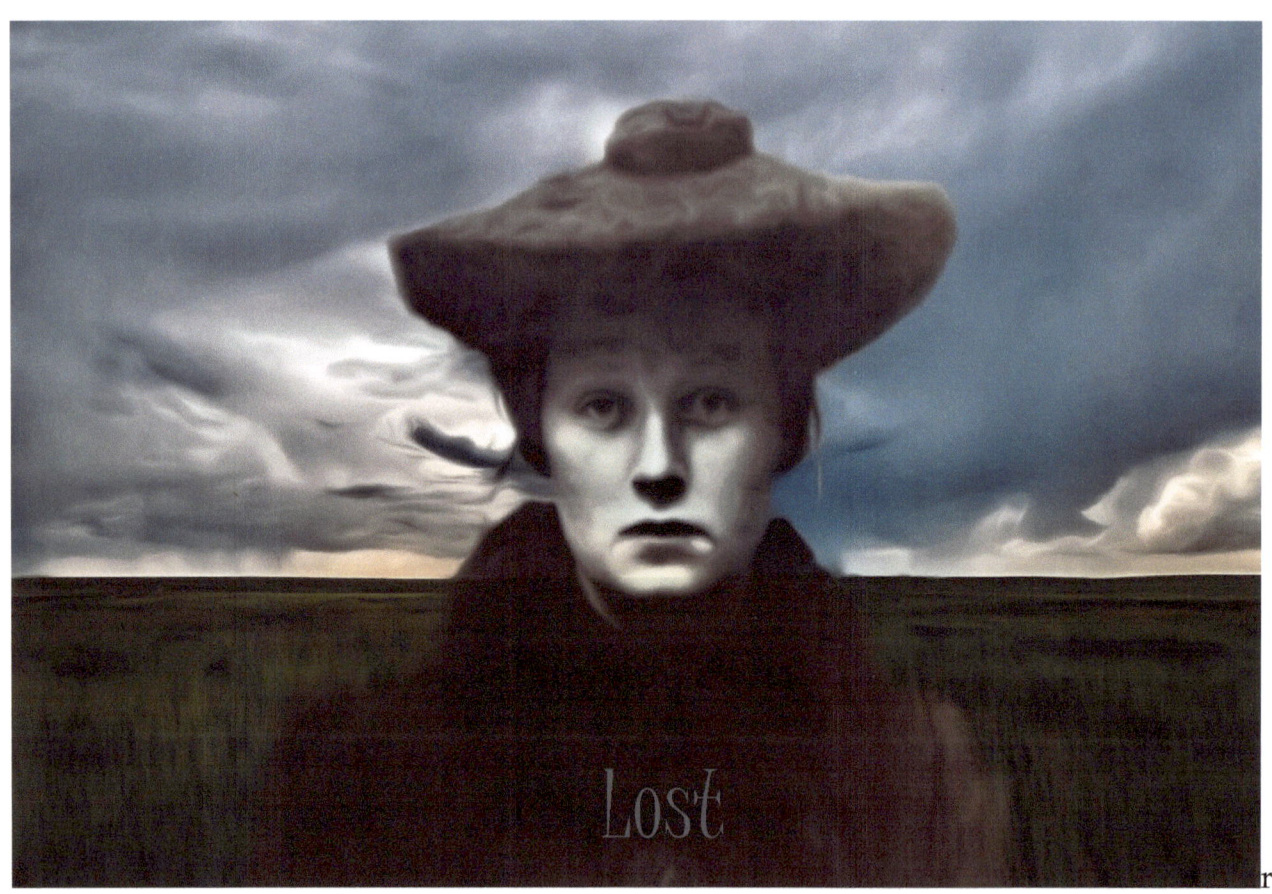

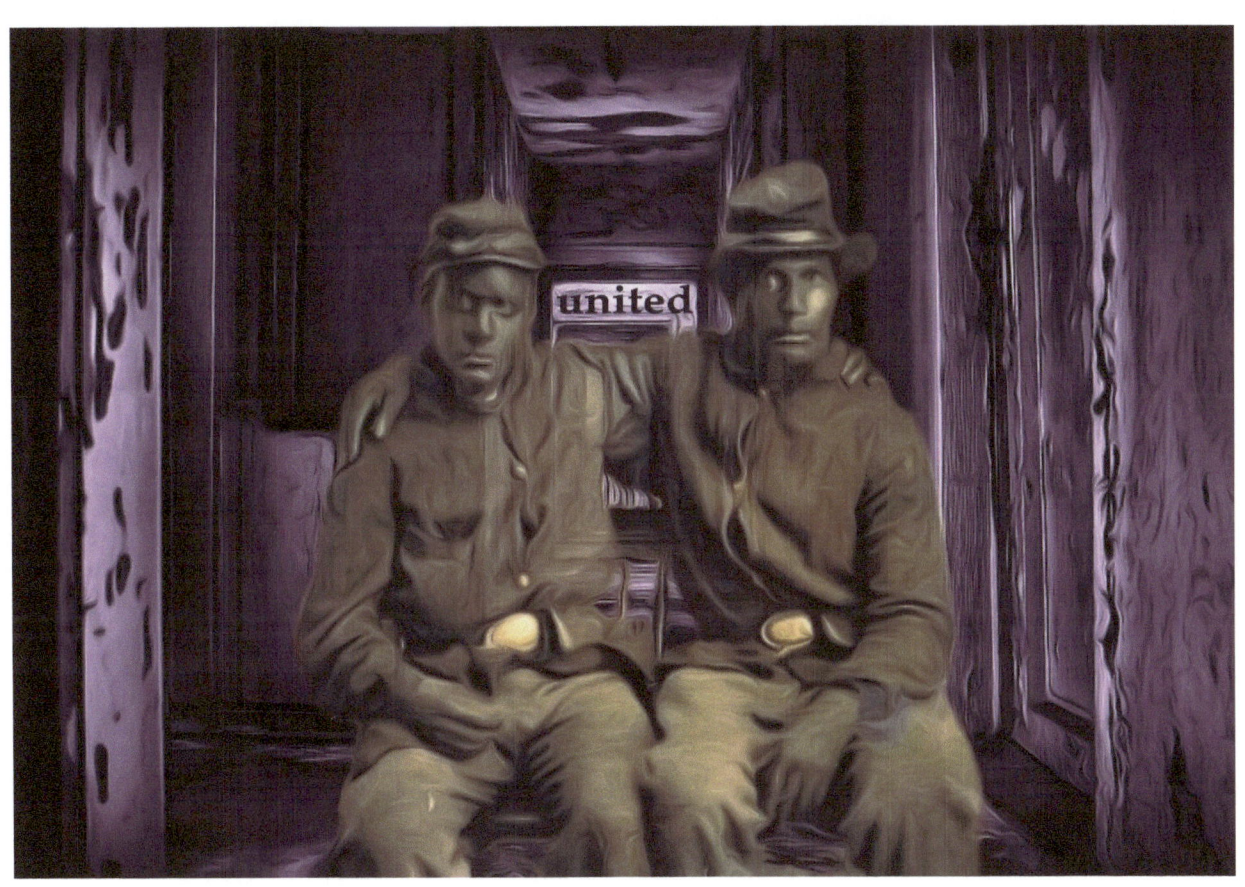

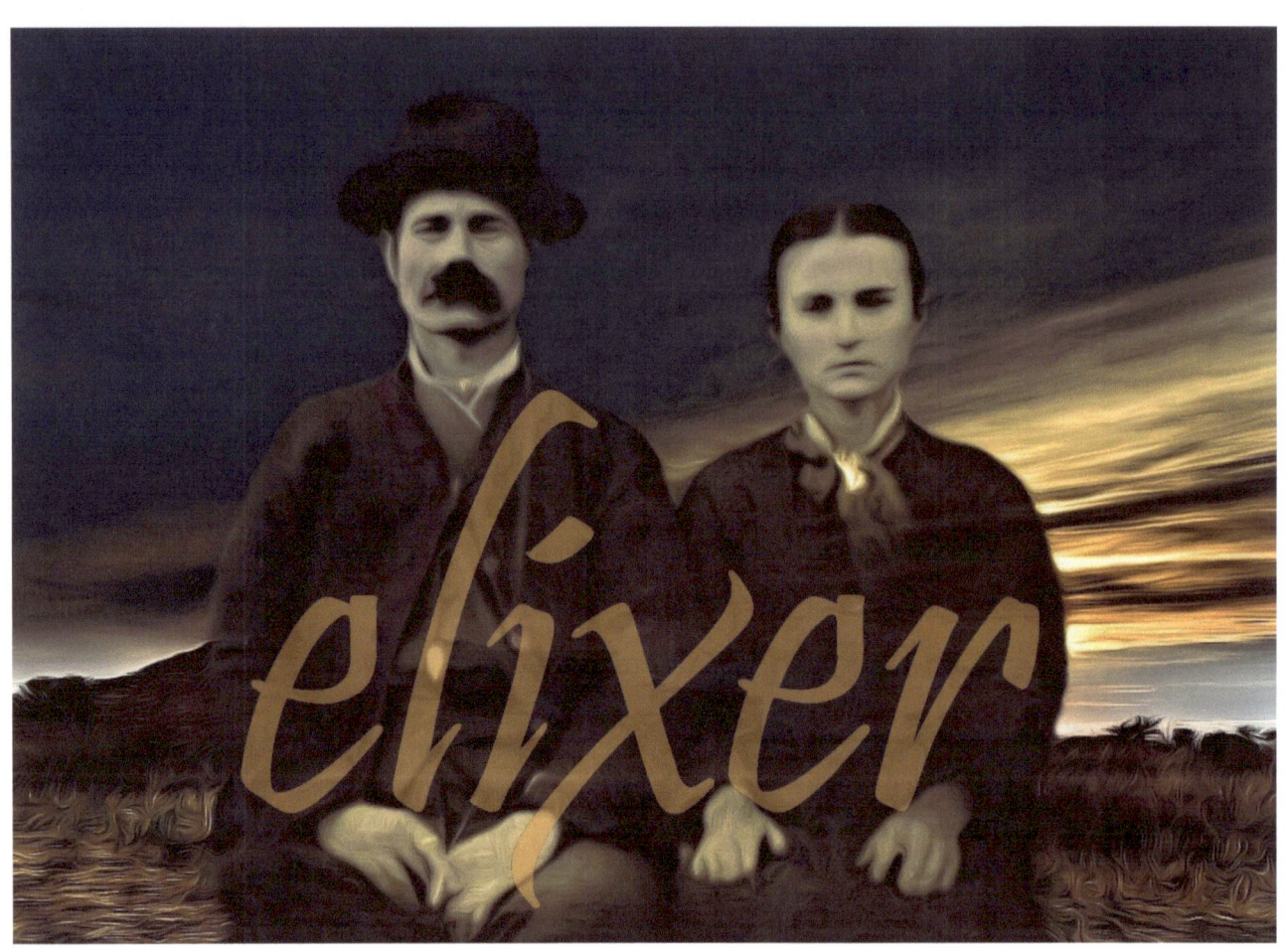

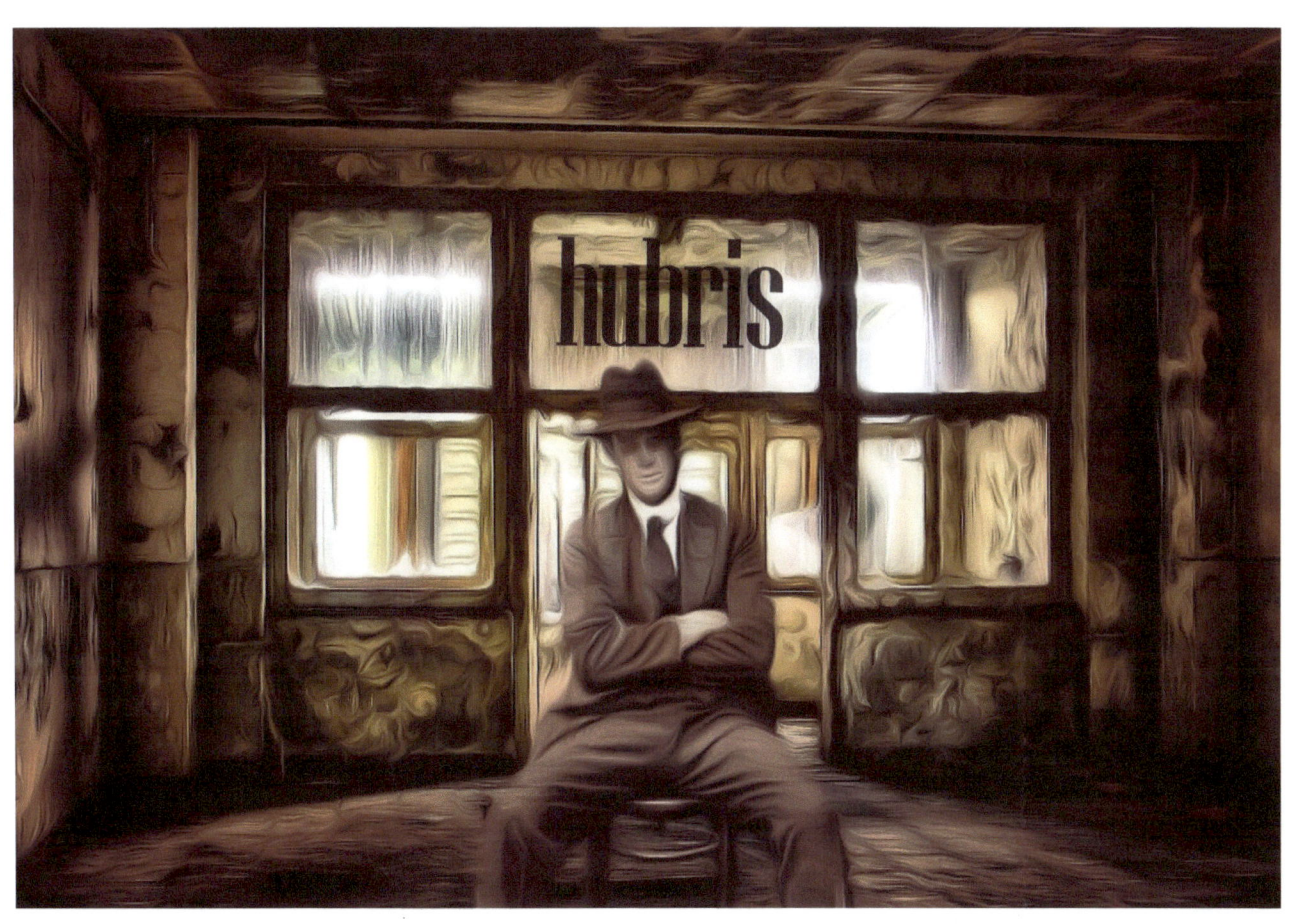

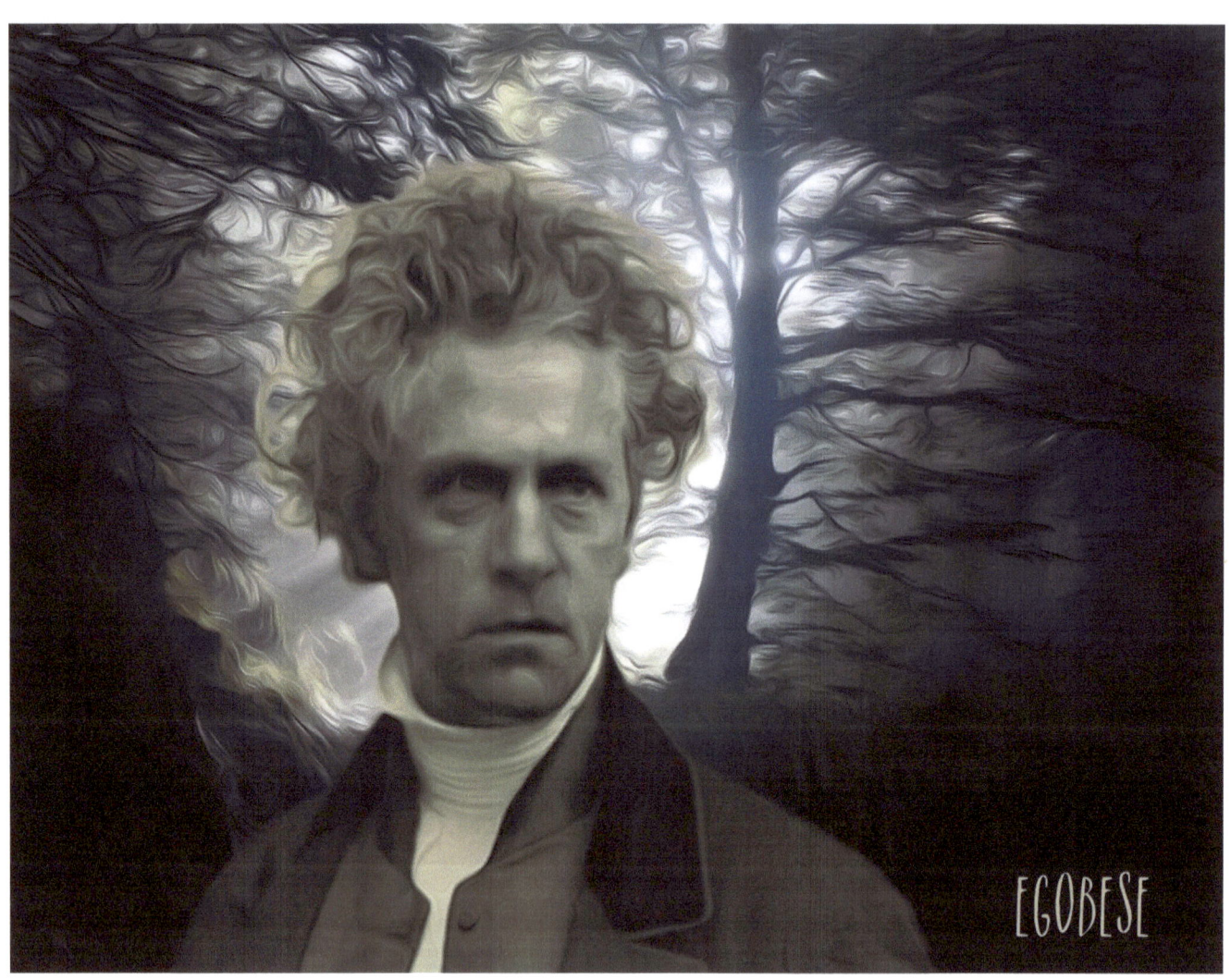

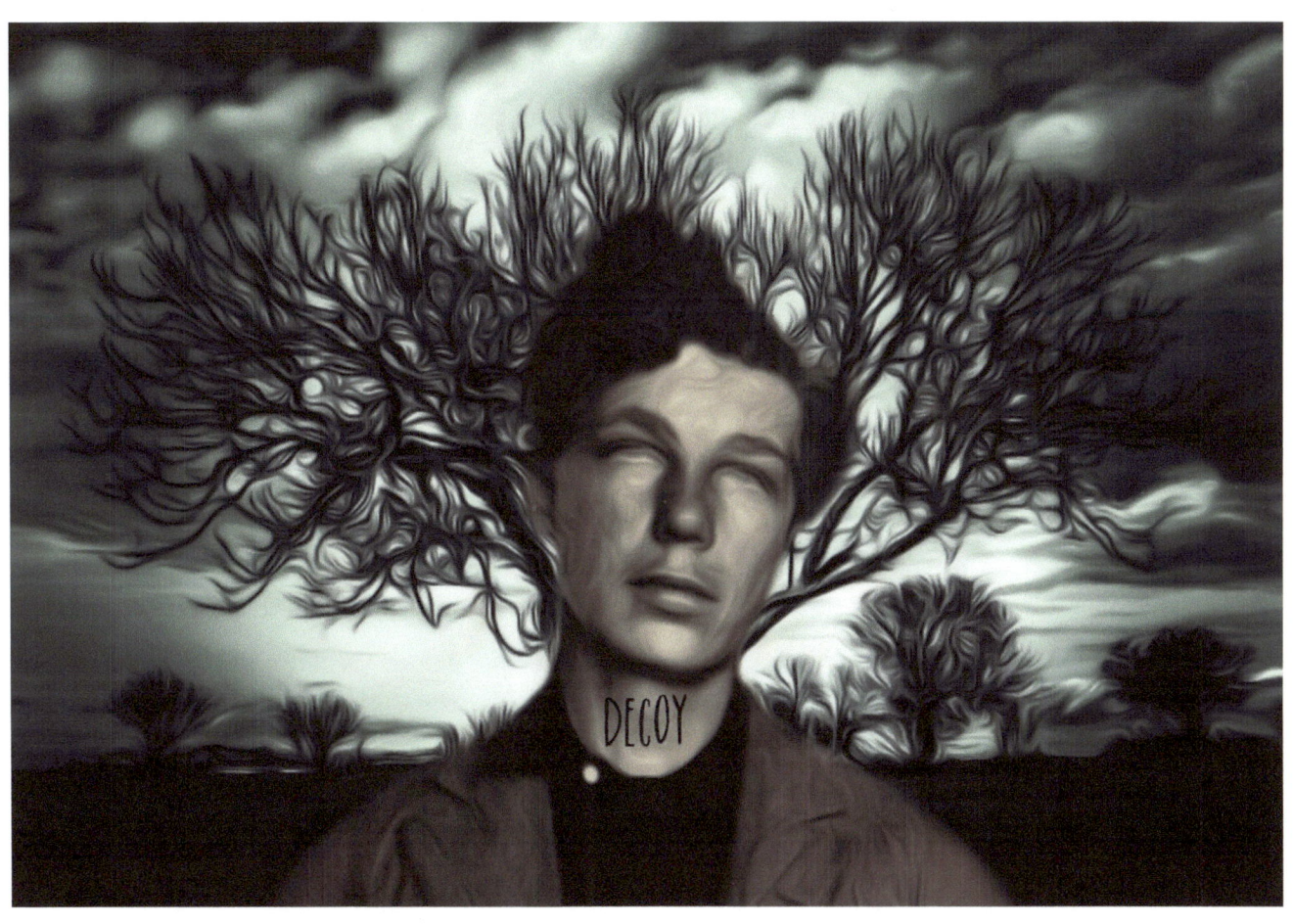

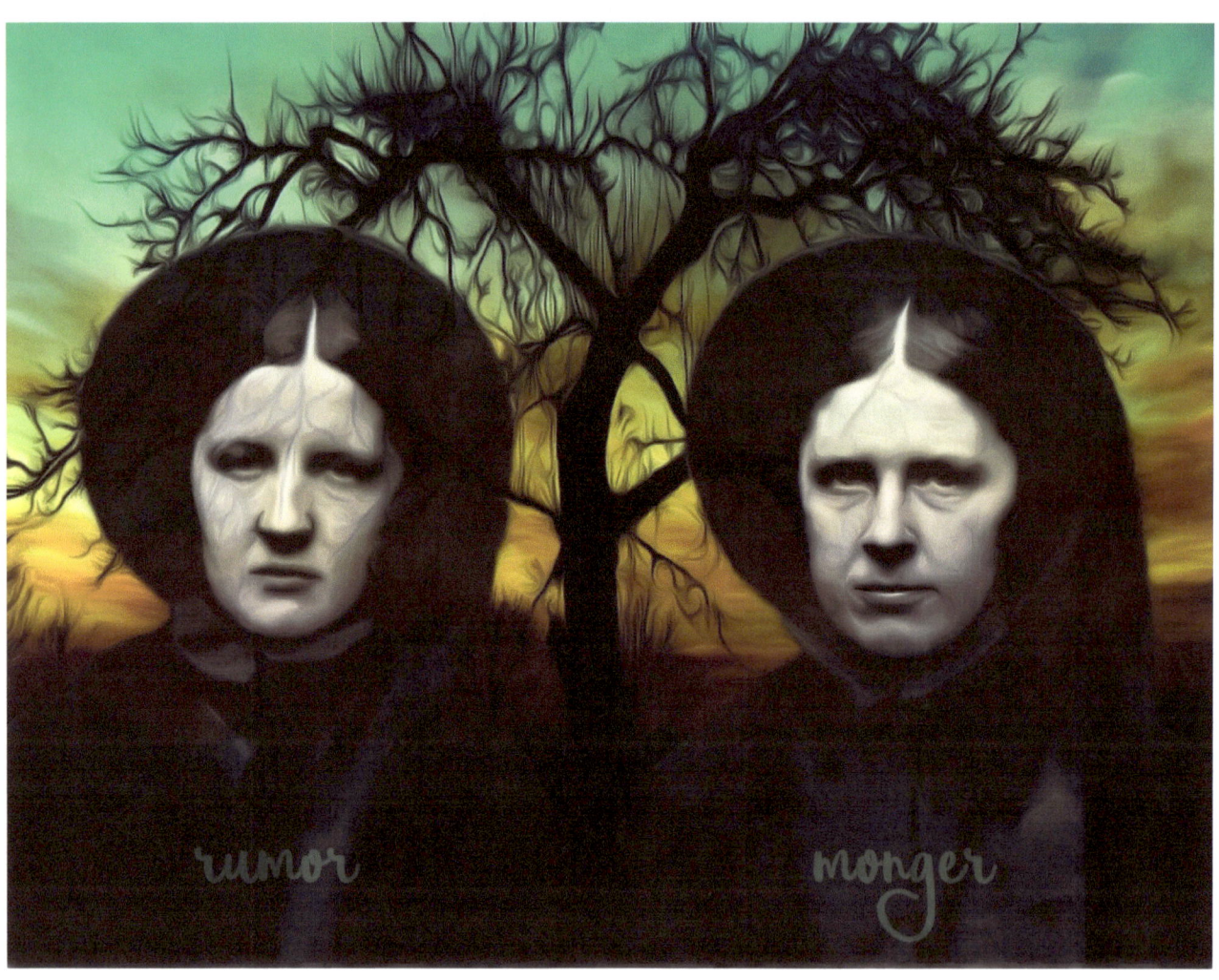

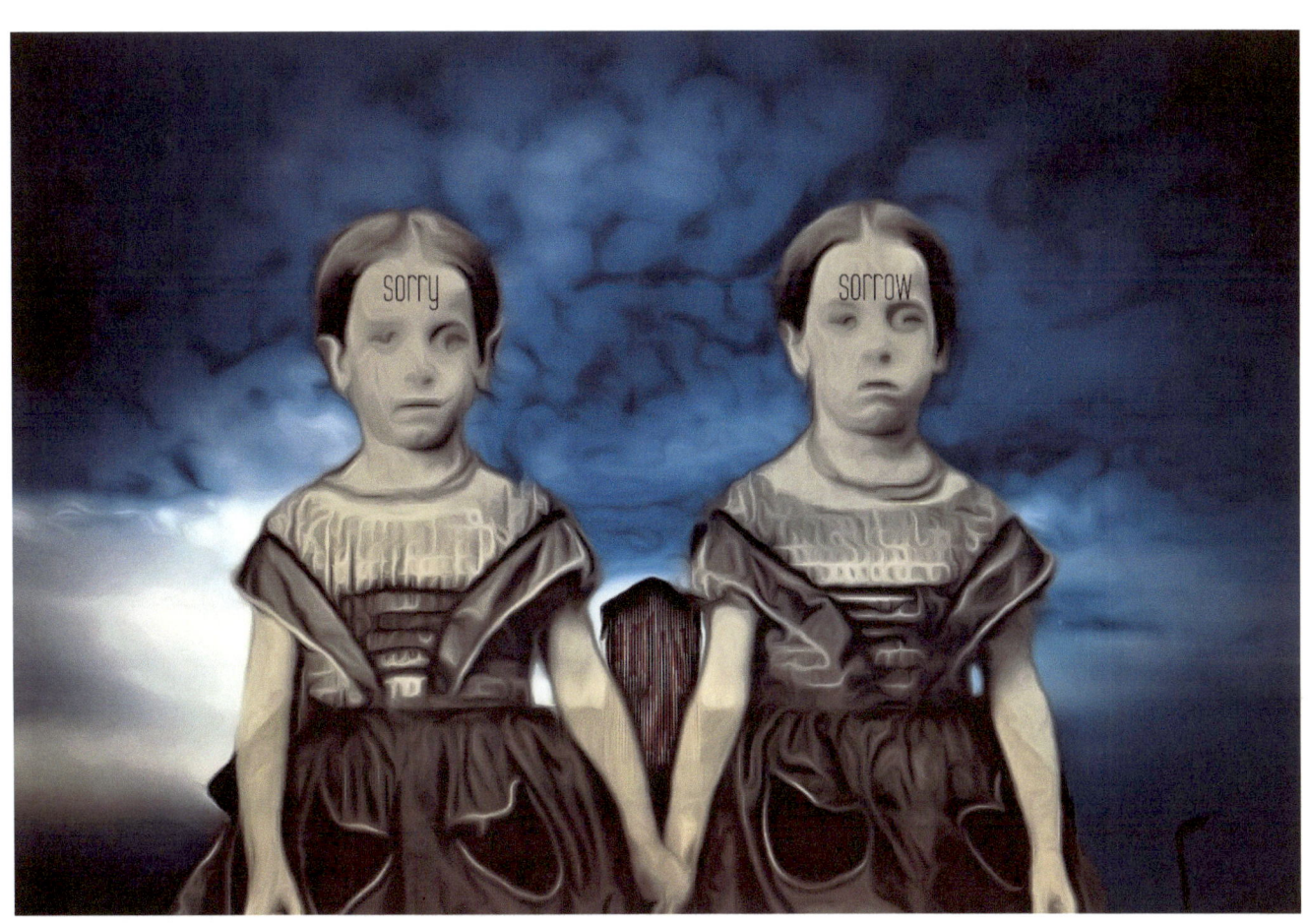

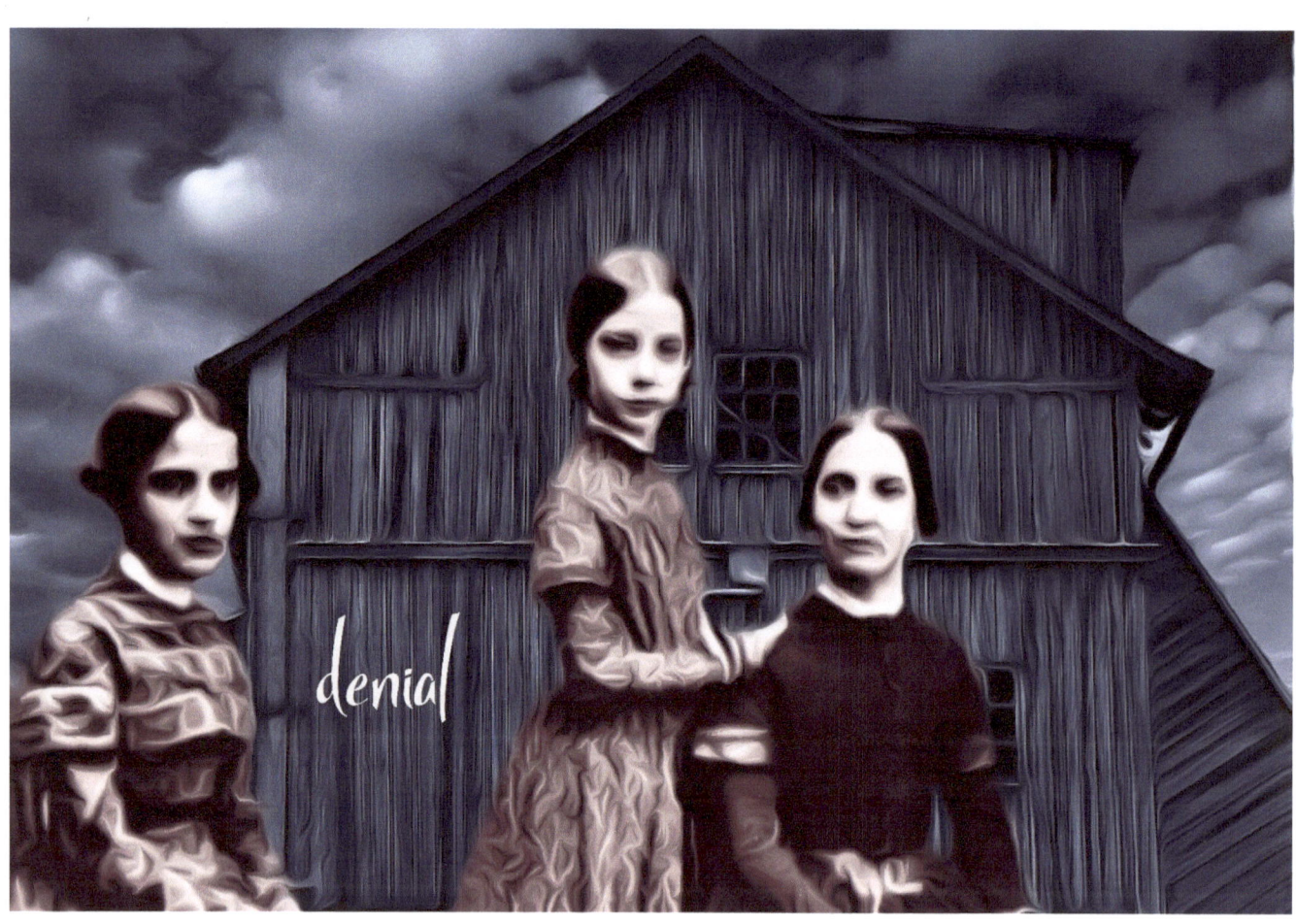

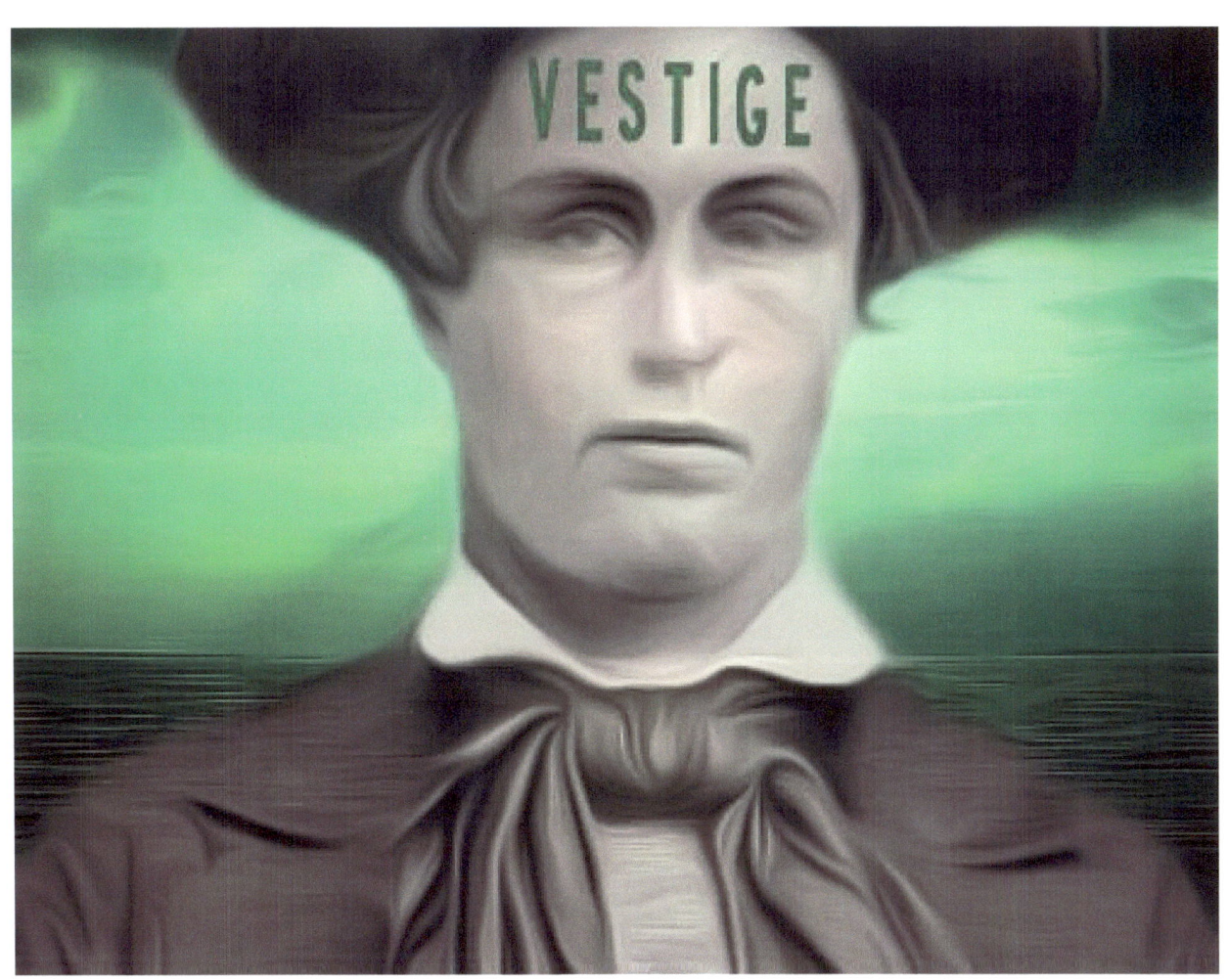

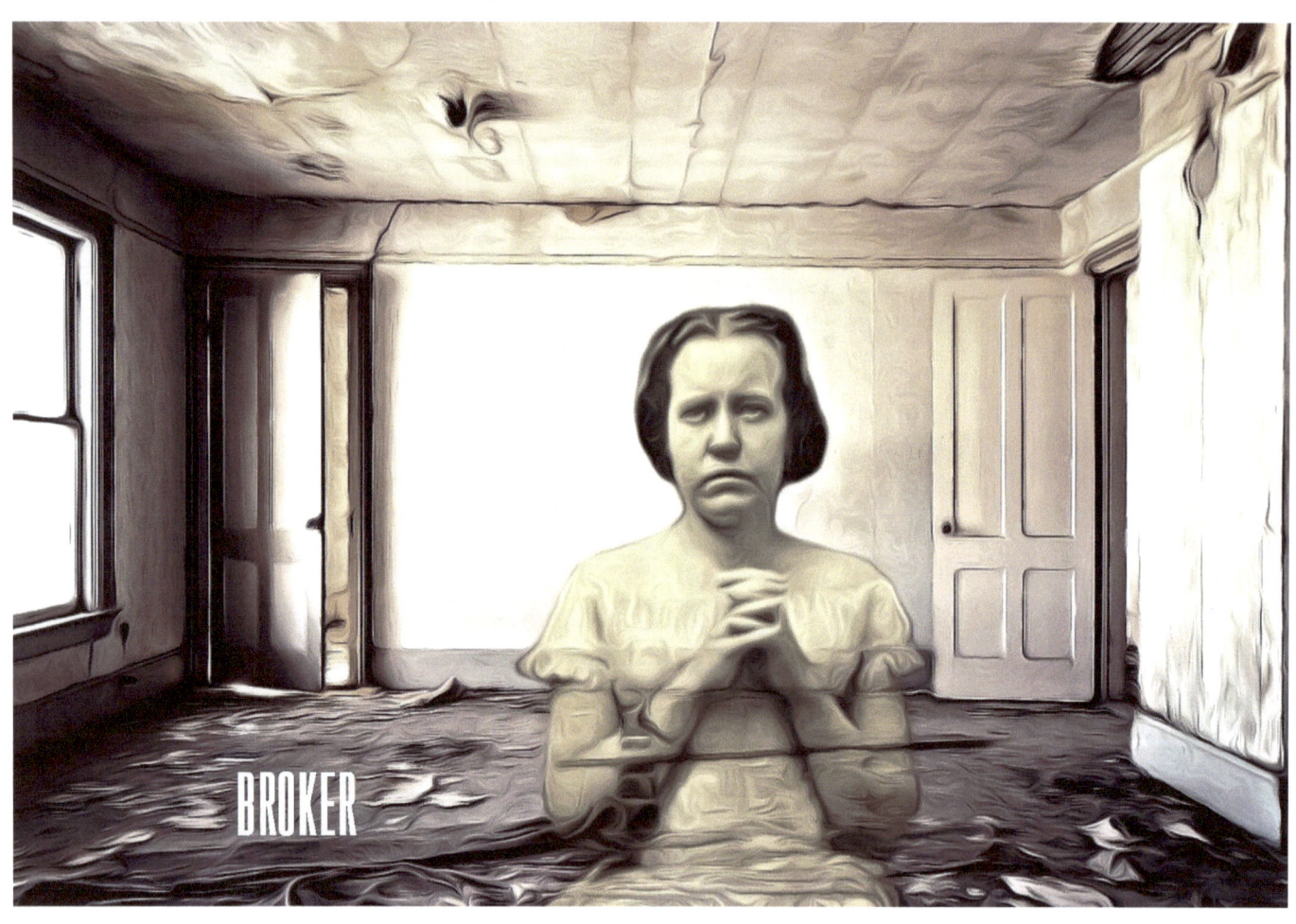

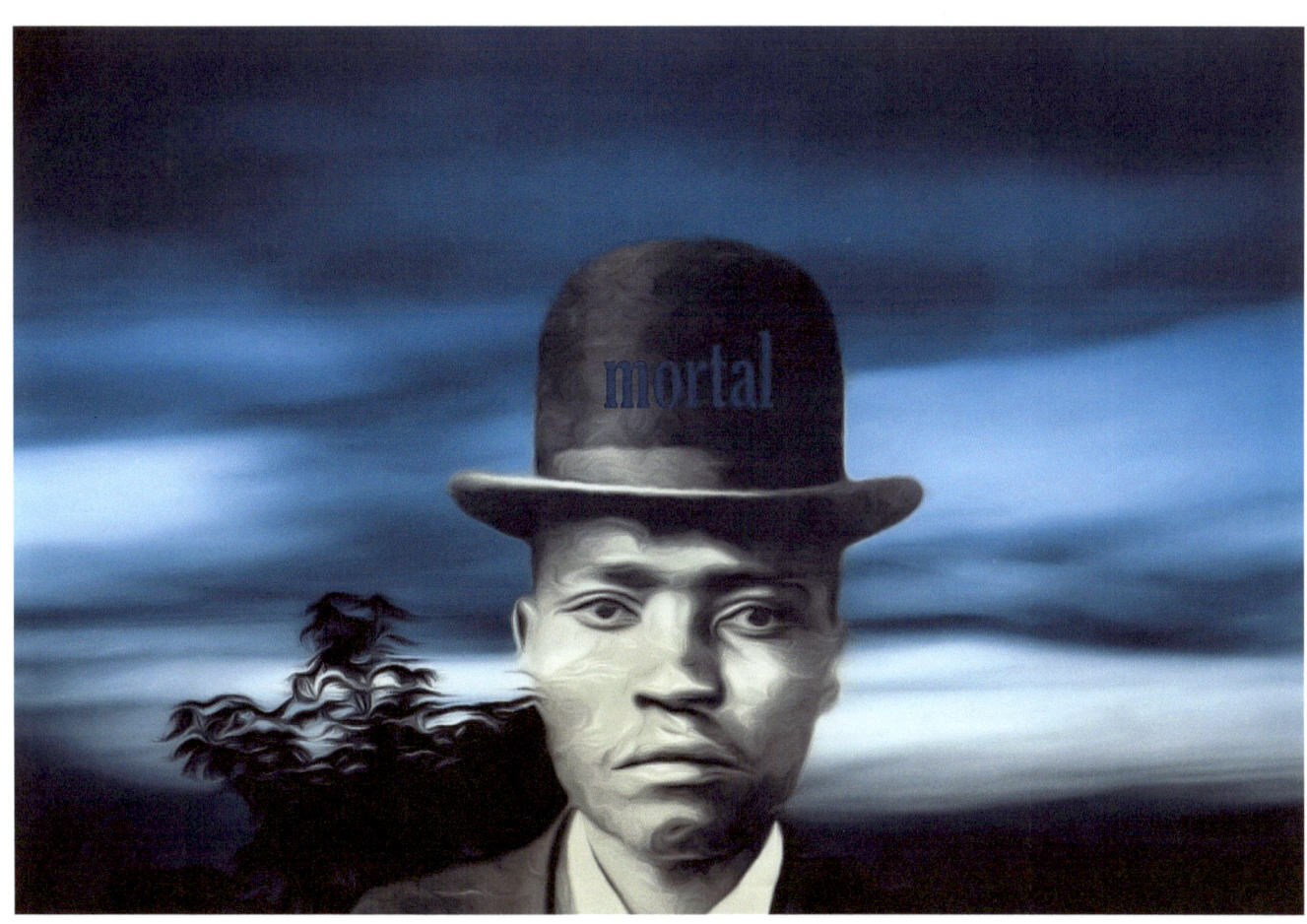

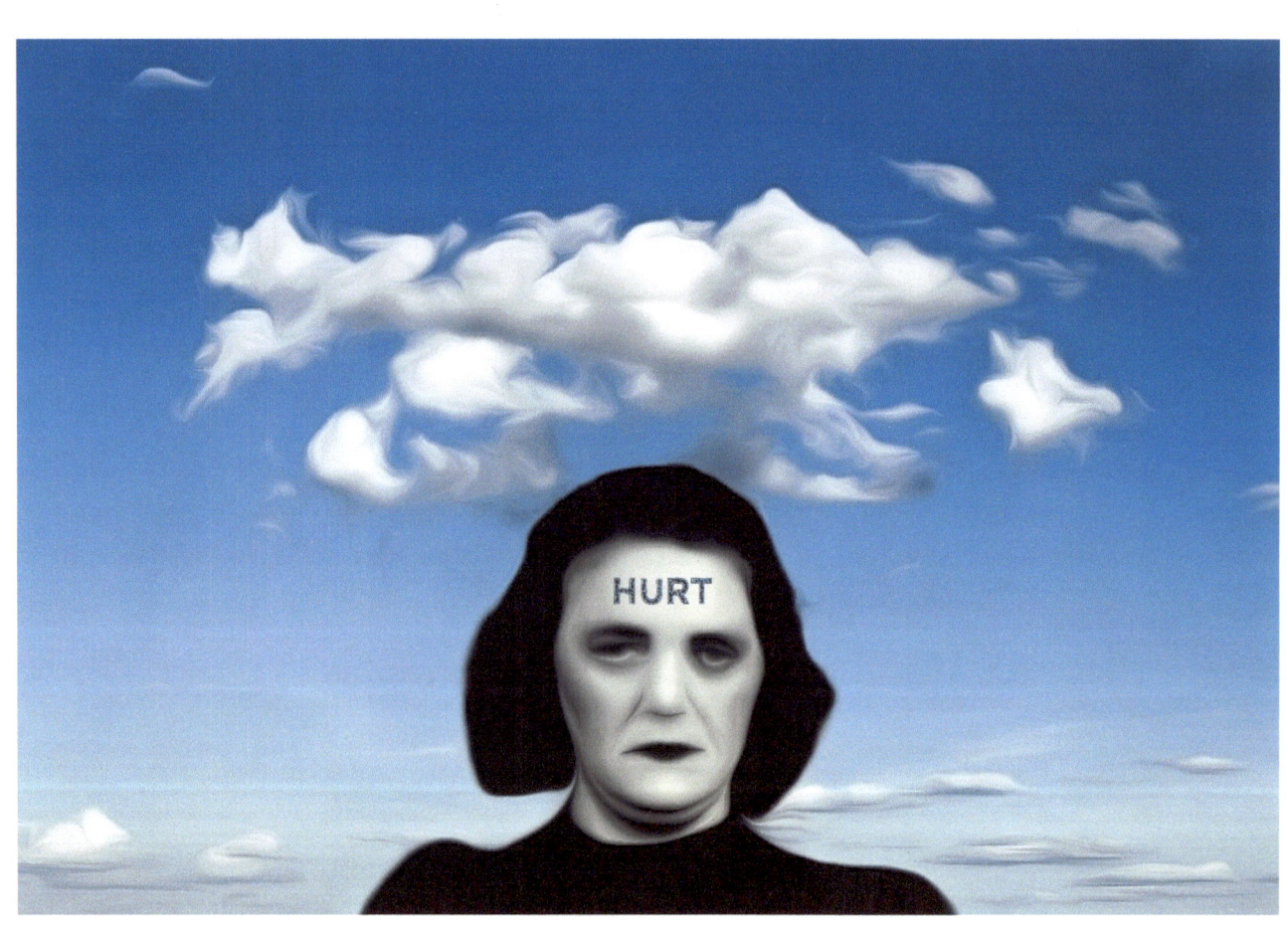

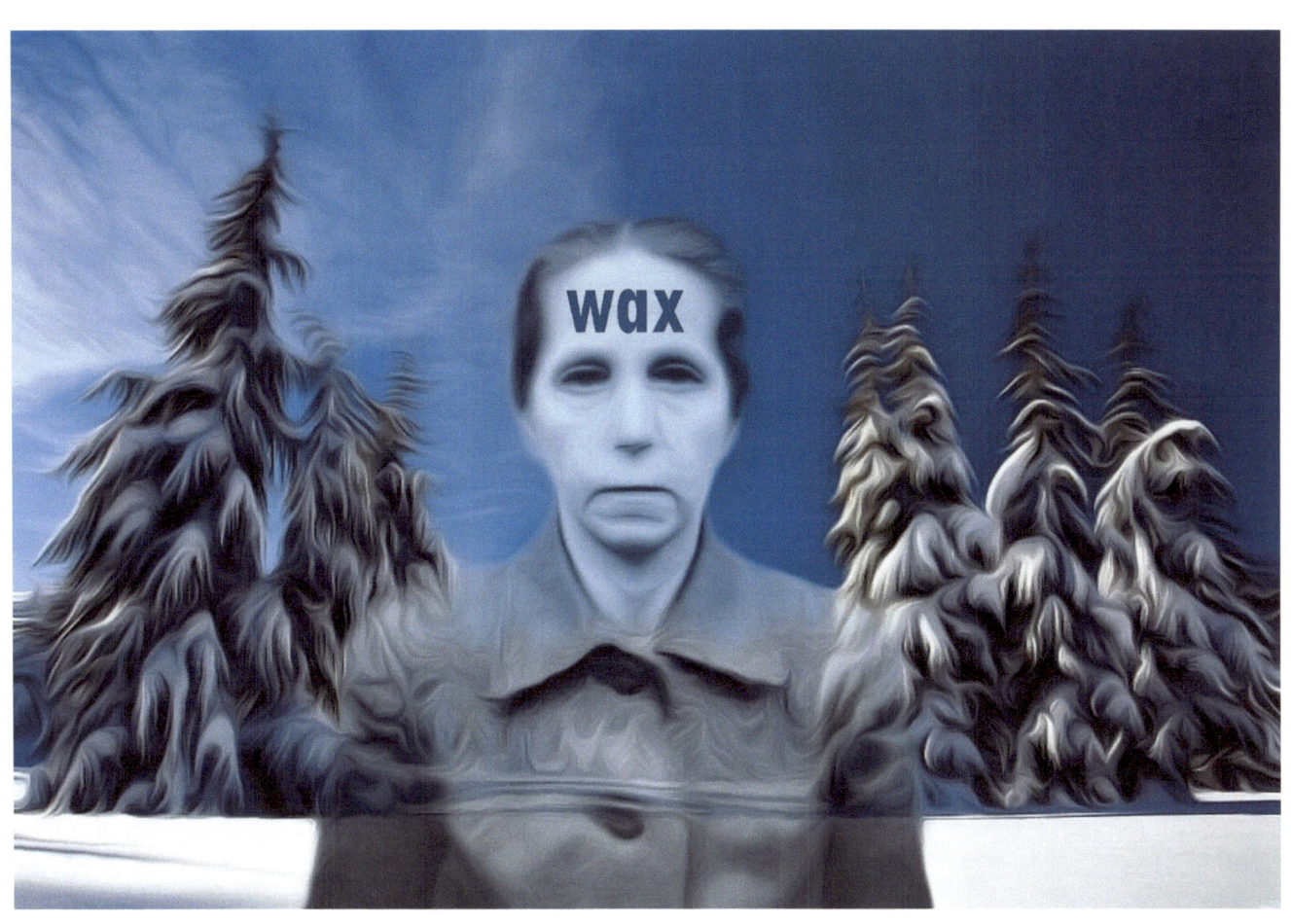

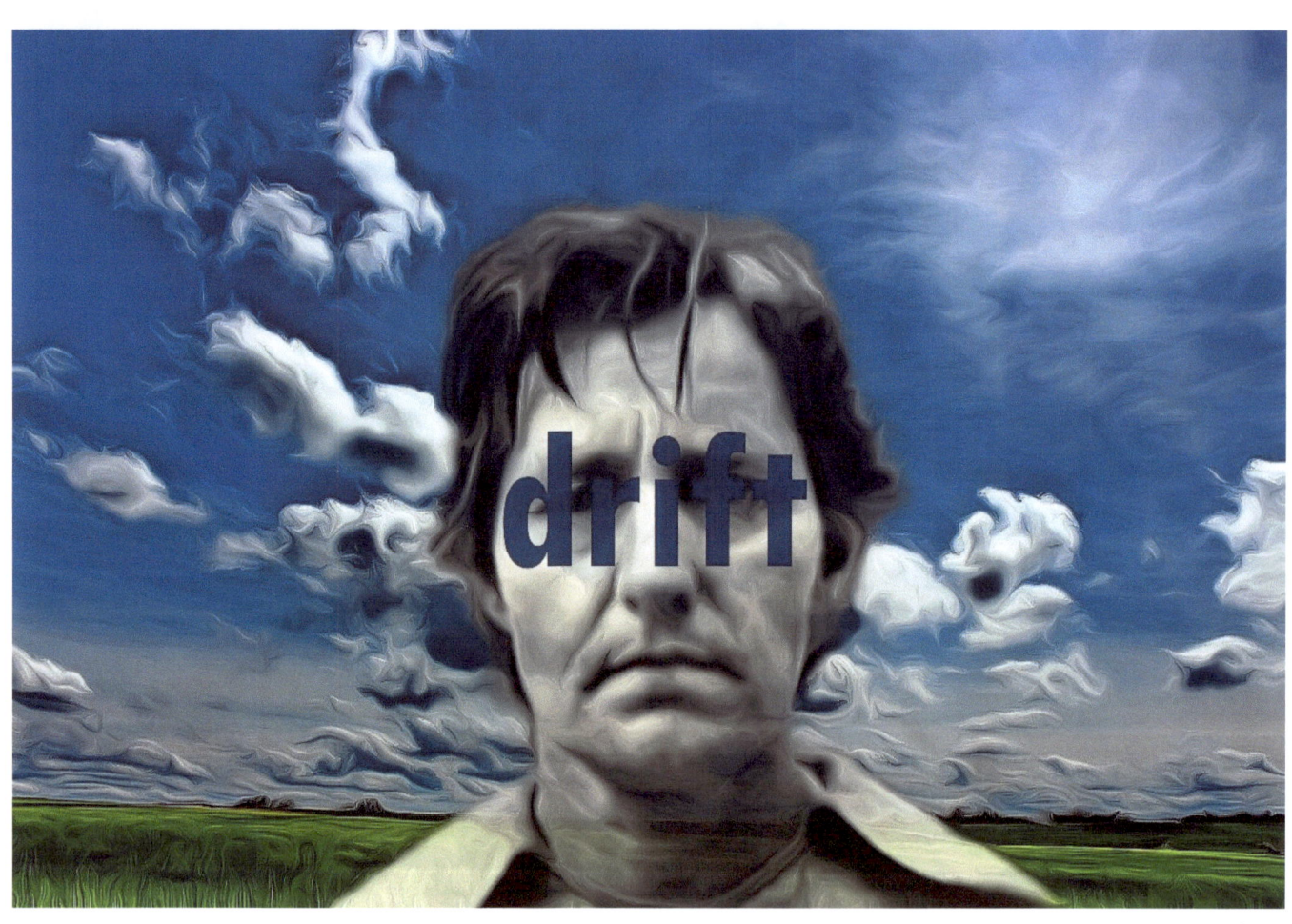

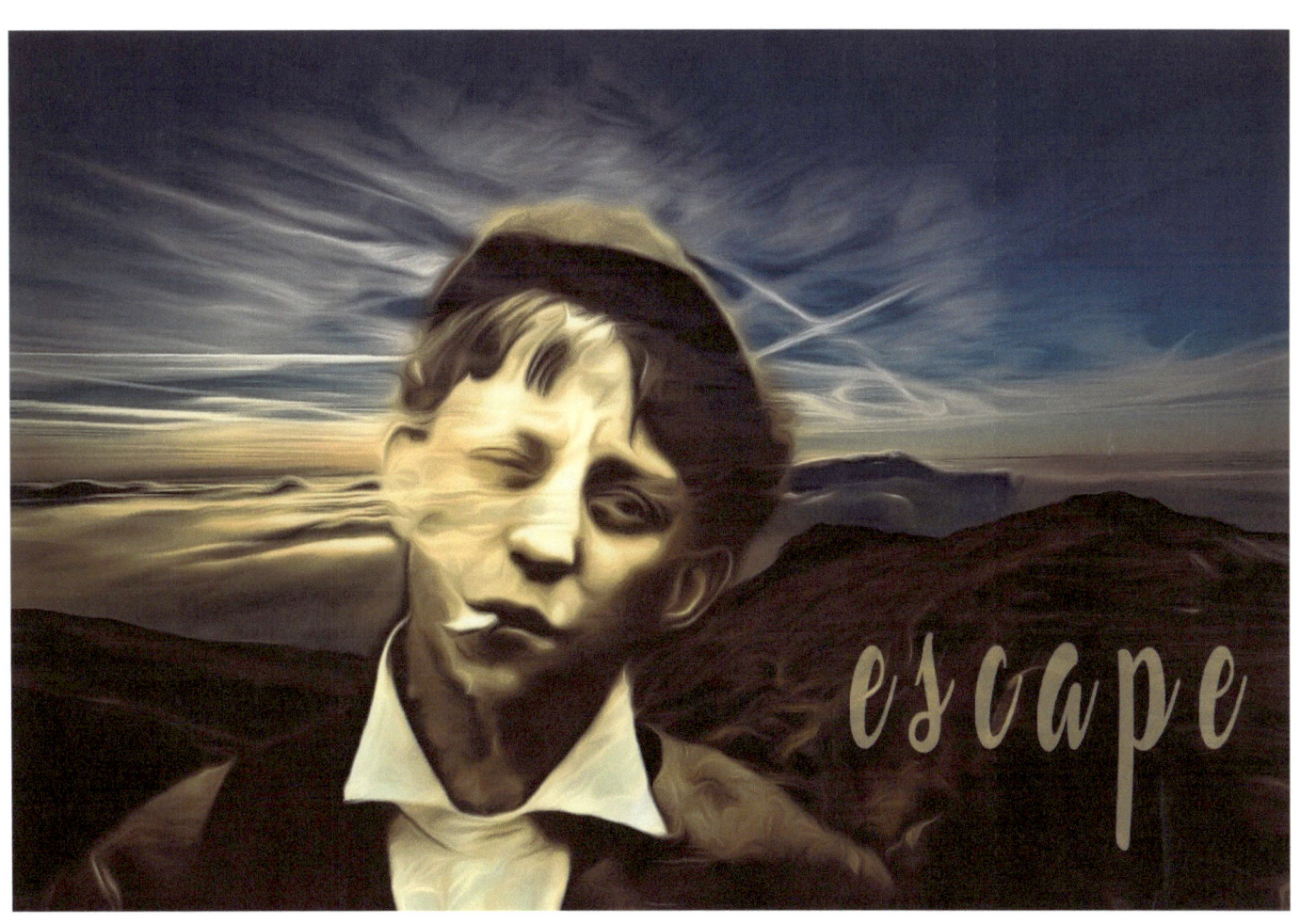

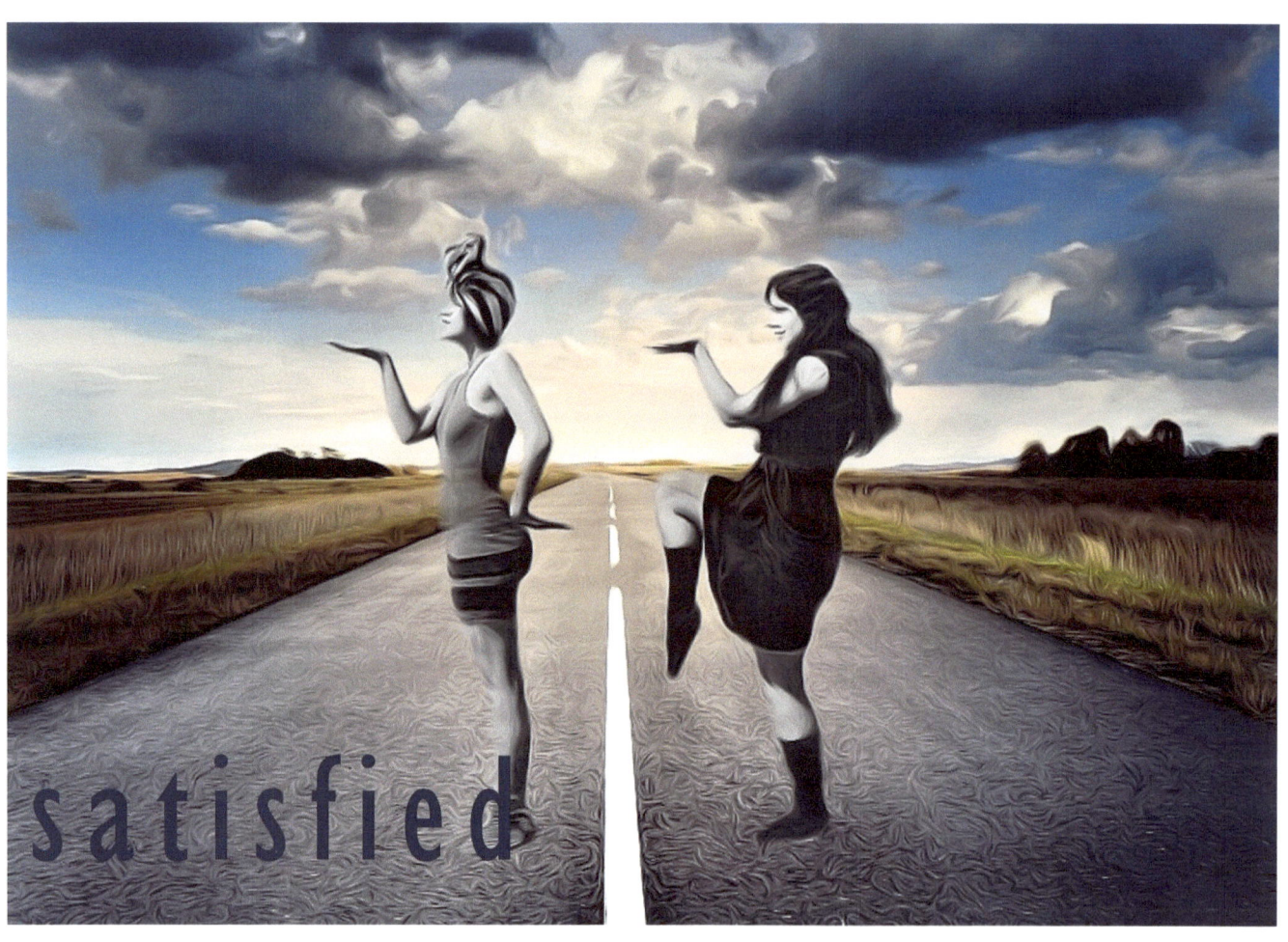

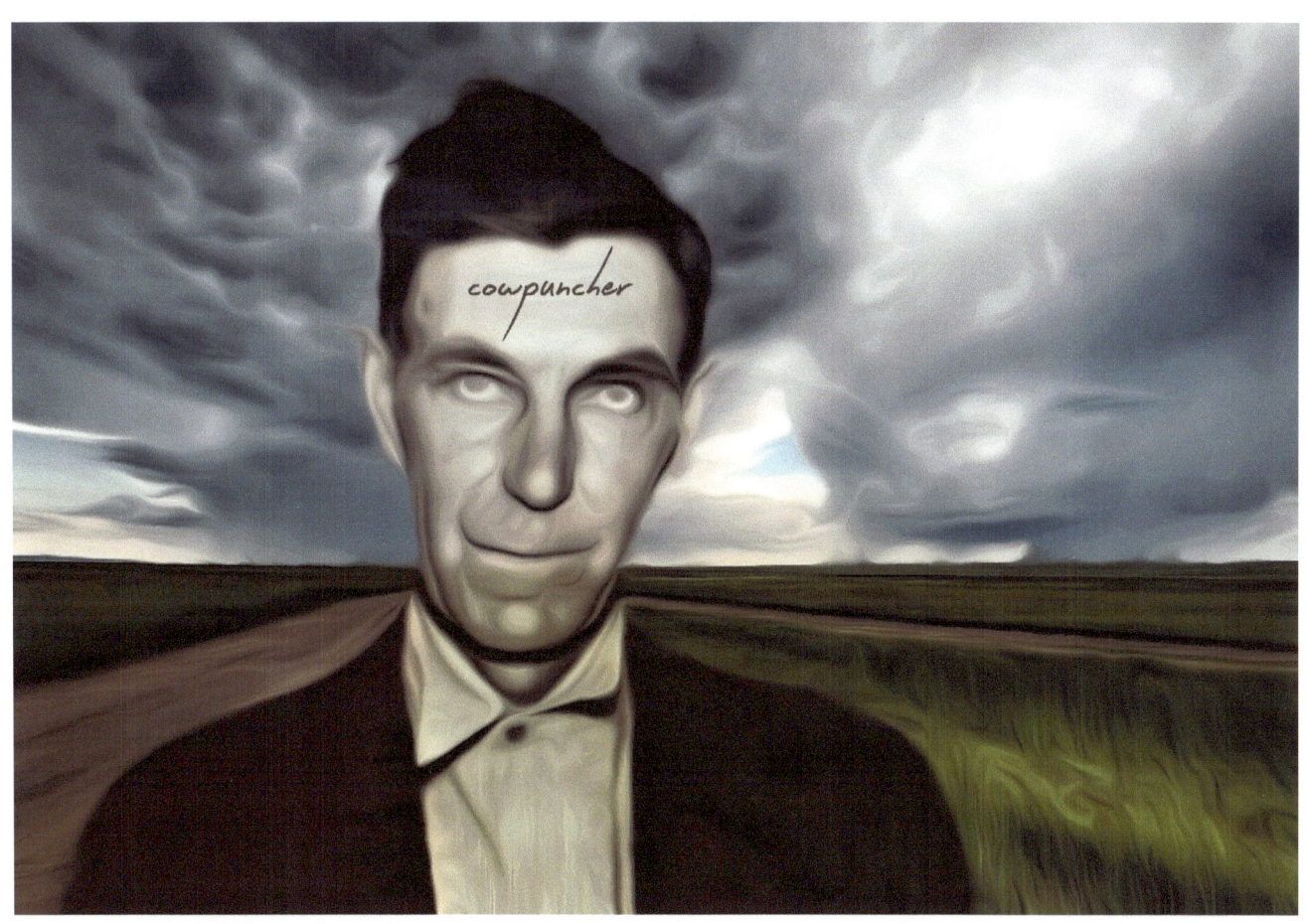

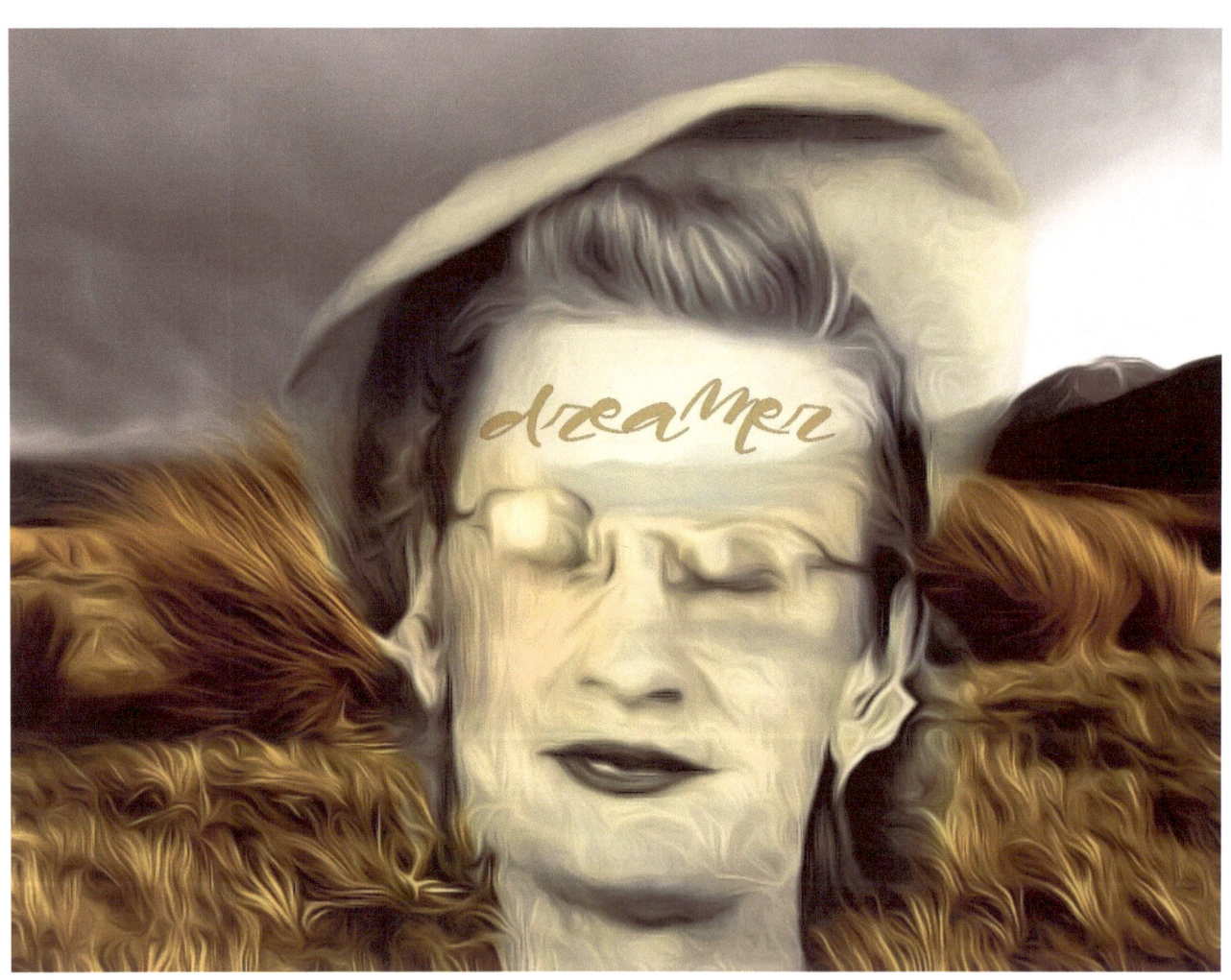

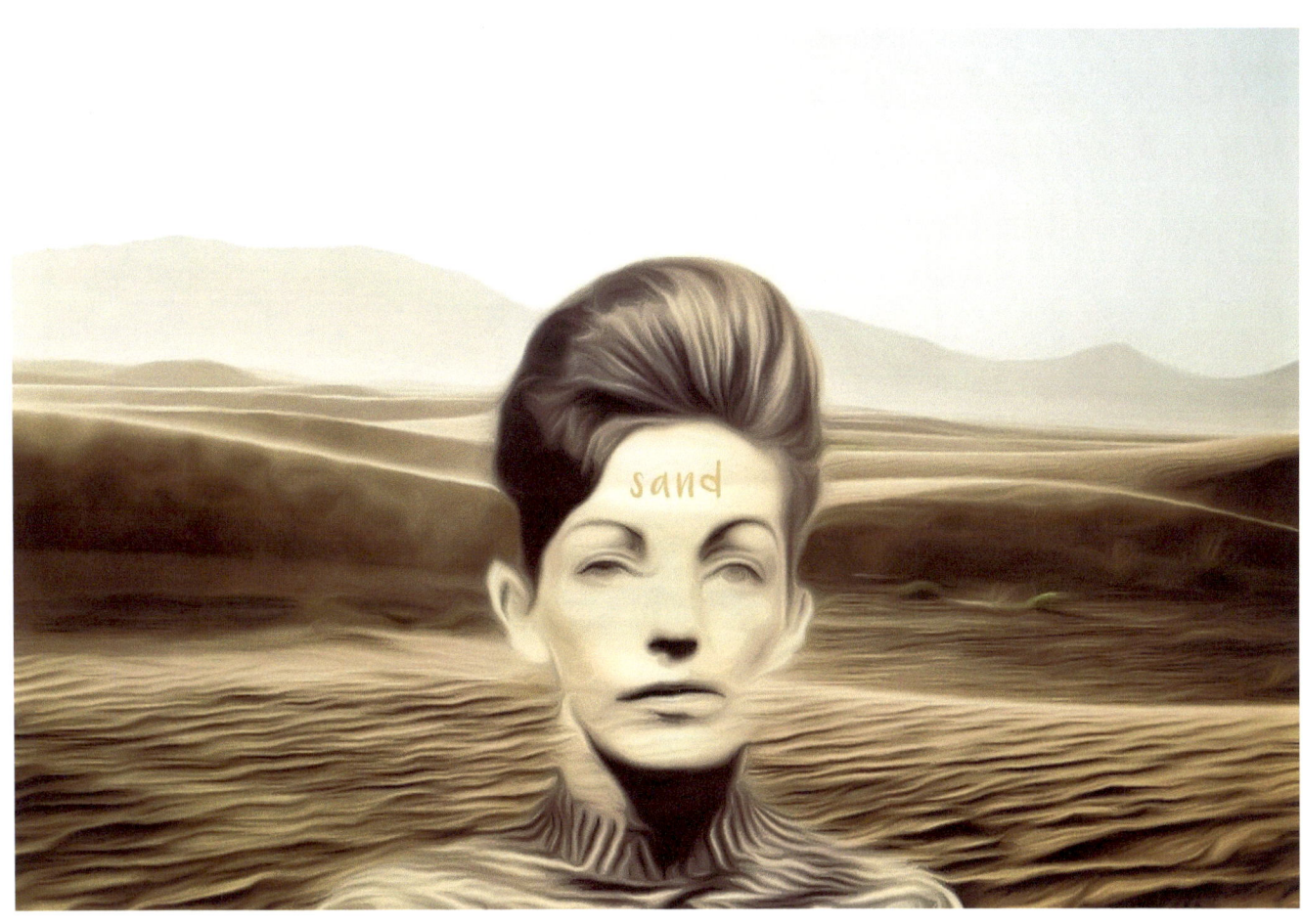

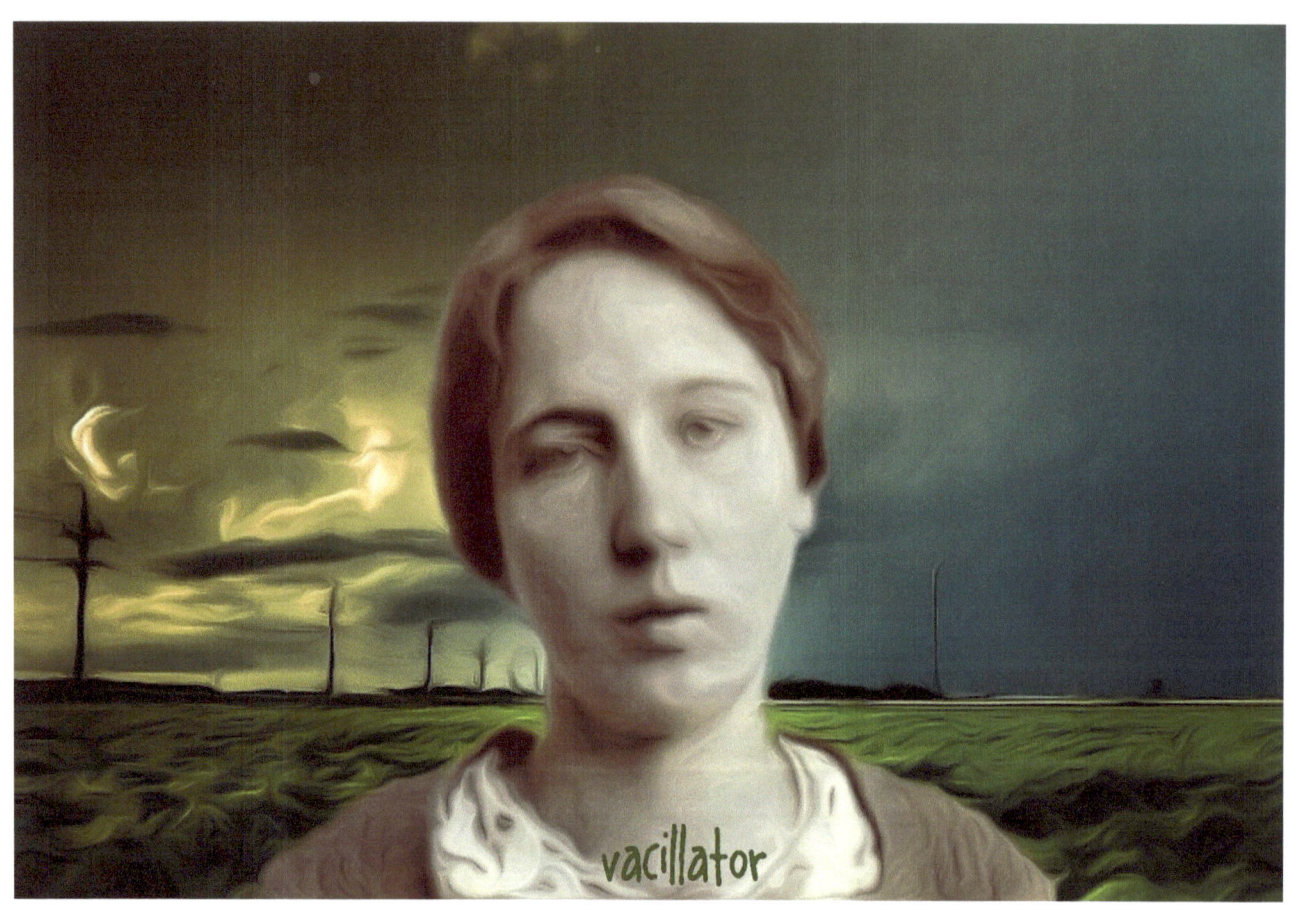

Bio
Ashley Parker Owens is an Appalachian writer, poet, and artist living in Richmond, Kentucky. She has an MFA in Creative Writing from Eastern Kentucky University and an MFA in Visual Arts from Rutgers University. Reach her at parker.owens@gmail.com.

Artist statement
My micro-visual poems are only one or two words combined with an image. The words or phrases are vague and the viewer can explore multiple meanings, resembling a Rorschach test or a writers' prompt.

To make digital paintings, I combine parts of photos and illustrations to create a unique image. I alter the images to blend them into a coherent paradigm with a strong foreground/background/phrase combination, hoping to spark a story in the viewer's mind.

Images were made using Artweaver, Corel Photo Paint, and Zoner Photo Studio. All image parts are from photos and illustrations in the public domain, and do not require attribution.

Acknowledgements
"Hurt," "Hubris," and "Lost," Volume 6 of *The American Journal of Poetry*, 2019
"Decoy," "Sorrow Sorry," and "Heavy," *Cream City Review*, 2018
"Sorrow Sorry" and "Denial" were shown in the annual traveling Women of Appalachia Project,
 a year-long exhibition in 2018-2019. "Sorrow Sorry" was published in the WOAP
 annual catalogue.
"Decoy" won third place in the American Art Awards 2019 manipulated digital photography under a different title.

Copyright 2019, Ashley Parker Owens

www.ingramcontent.com/pod-product-compliance
Lightning Source LLC
Chambersburg PA
CBHW041300180526
45172CB00003B/904